HOW TO DRAW MANGA

Vol. 7 Amazing Effects

HOW TO DRAW MANGA Volume 7: Amazing Effects
by Mikio Kawanishi

Copyright © 1998 Mikio Kawanishi
Copyright © 1998 Graphic-sha Publishing Co., Ltd.

This book was first designed and produced by Graphic-sha Publishing Co., Ltd. in Japan in 1998.
This English edition was published by Graphic-sha Publishing Co., Ltd. in Japan in 2003.

Cover drawing: Kazuaki Morita

English title logo design: Hideyuki Amemura
English edition layout: Reminasu
English translation: Língua fránca, Inc. (an3y-skmt@asahi-net.or.jp)
Planning editor: Motofumi Nakanishi (Graphic-sha Publishing Co., Ltd.)
Foreign language edition project coordinator: Kumiko Sakamoto (Graphic-sha Publishing Co., Ltd.)

Distributor:
Japan Publications Trading Co., Ltd.
1-2-1 Sarugaku-cho, Chiyoda-ku, Tokyo, 101-0064
Telephone: +81(0)3-3292-3751 Fax: +81(0)3-3292-0410
E-mail: jpt@jptco.co.jp
URL: http://www.jptco.co.jp/

First printing: June 2003

ISBN 4-88996-084-8
Printed in China by Everbest printing Co., Ltd.

Using This Book

This book discusses *manga* techniques used by Japanese artists, presenting them in an authentically Japanese format that is both fun and easy to understand. Consequently, all of the *manga* appearing in this volume is read from right to left. Refer to the guide below to see how this *manga* should flow. See what amazing effects this book will have on your own.

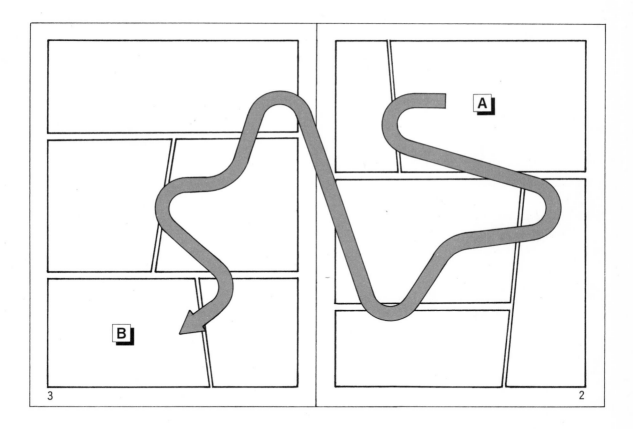

4

So, what's wrong with it?

Oh, I see.

Shock!

Appeal!?

Well, more than the drawing being bad, it's just lacking appeal.

L..l...lacking appeal?

Don't you think you're being a little melodramatic?!

Waaaaah!

Ok. Let me ask you a question.

What were you thinking when you drew this robot?

So, what exactly do you mean by "lacking appeal"?

why?

Um, that's not what I meant.

I was thinking that I'd really like a telephone card with Ryoko Hirosue's picture on it. Plus, that I wanted some katsudon (fried pork cutlet).

Gulp!

...

Nuthin' really.

What I meant was how did you conceive this drawing?

So, that's what you meant.

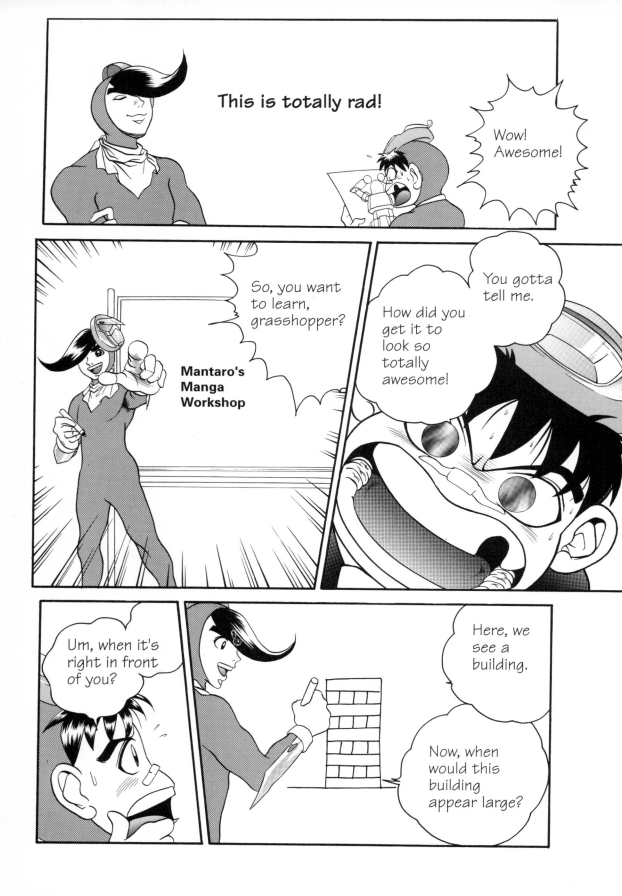

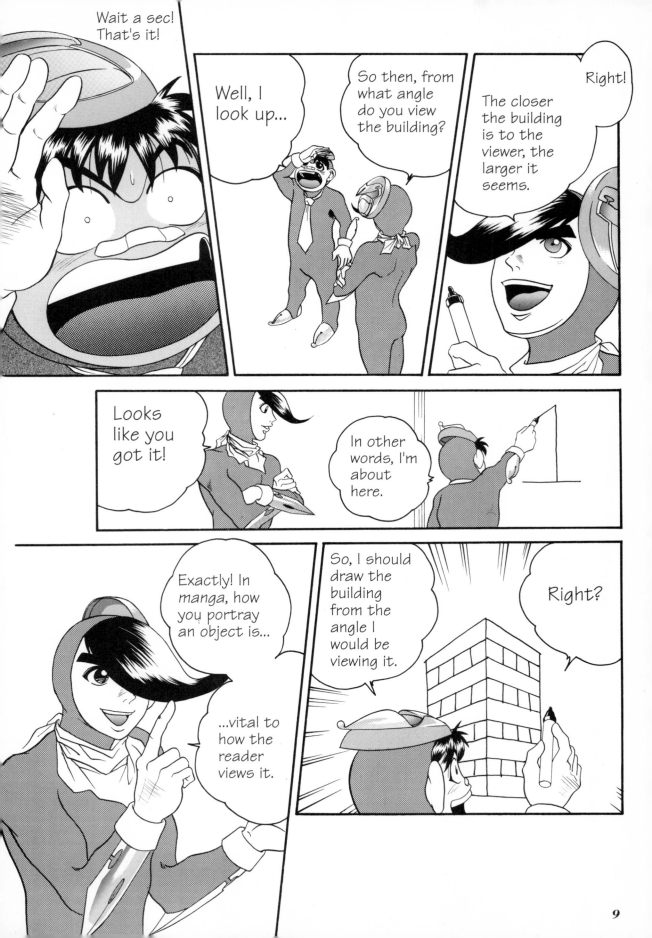

Wait a sec! That's it!

Well, I look up...

So then, from what angle do you view the building?

Right! The closer the building is to the viewer, the larger it seems.

Looks like you got it!

In other words, I'm about here.

Exactly! In manga, how you portray an object is...

...vital to how the reader views it.

So, I should draw the building from the angle I would be viewing it.

Right?

Contents

Purpose

I would like to dedicate this book to those readers who are committed fans of *manga* and who hope to improve their *manga* skills.

So, you now know how to design your individual characters and have grown pretty comfortable with drawing backgrounds. You have been tossing around ideas for stories for some time now. However, it is still important for you to learn how to layout the *manga* panels and how to portray the scenes of the story within those panels.

With respect to portrayal, like in film the portrayal of a character, the visual composition, the panel layout, the sounds and voices, etc. are all components of the synergistic arts of *manga*.

Sprinkled throughout with advice and informative nuggets needed to complete a work of story *manga*, this edition offers the definitive word on improving *manga* skills.

If you are planning on buying a book like this, do it now and make your artwork a cut above your friends'.

Chapter I

The Basics in Composition

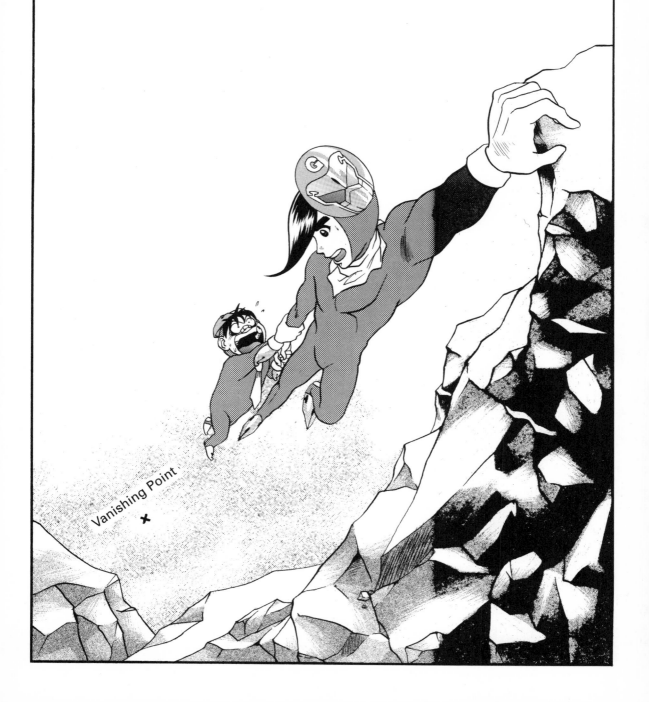

Vanishing Point

Once upon a time, *manga* consisted of abstract features practically symbols in nature, resulting in abbreviated artwork. The artwork within a given panel was flat, and the compositions repetitive.

Today, manga has dramatically evolved, and the majority of works on bookshelves exhibit both a high level of artistic skill and heightened realism.

A likely major cause of this development in *manga* was "space" in the panels, which gave the characters freedom of movement, expanding the breadth of artistic expression. This "space" is generated by the panel's composition.

Anticipating the effects of perspective can create space even in scene like that to the right by transforming it into something like the figure below. As a result, the character is now able to move freely within the panel. The breadth of expression has been expanded, and a more attractive composition has been made possible.

Just shifting the composition clarifies the sense of distance between the character and the dog in pursuit, allowing the character's anxiety to be conveyed much more keenly.

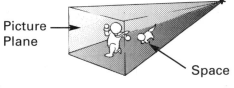

1. A Well-planned Composition Brings the Characters to Life.

"I tried to create this hyper-action scene, but it just seems to lack force."

"I jam-packed an action scene into a large-format panel, so it should have resulted in a key scene, but it just seems to be lacking something."

Artists often are frustrated by having to redraw key scenes that just will not come out as imagined.

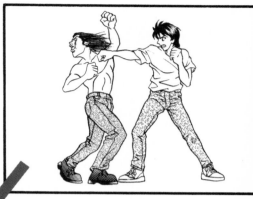

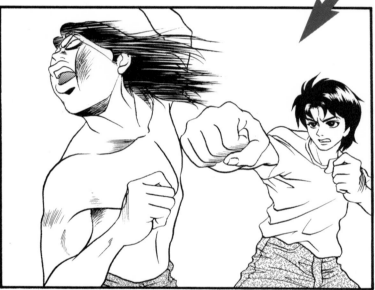

The likely cause of this frustration is that the artist uses the "picture in his mind" as the overall image, rather than devising a composition that anticipates the 2-dimensional picture plane. "Composition" refers to the way the picture plane is composed. Establishing a composition that generates space within the picture plane will enable you, the artist, to move the characters freely within the panel.

Comparing the 2 figures above, the bottom figure's composition has more energy and force, don't you think?
Use your ingenuity to develop the composition.
This will result in a convincing composition, giving your artwork more appeal.

Make the Composition Move

For example, let's take a look at this character.

Assume that she is reacting in surprise to something (Fig. 1).

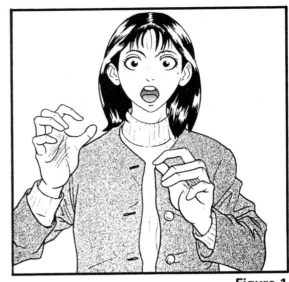

Figure 1

First, let's draw 2 bisecting lines across the composition to determine how it is structured (Fig. 2). This analysis reveals that the panel's composition (Fig. 1) is well centered.

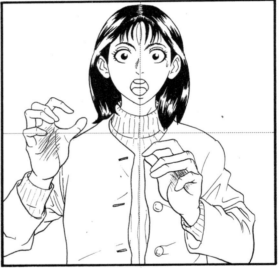

Figure 2

This panel is not particularly displeasing compositionally, but a slight shifting would illustrate the character's surprise more keenly. Let's try shifting the structural lines we drew in Fig. 2 off center.

I get it!

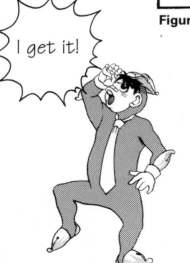

Setting up the character as in Fig. 3 reveals a potential effect.

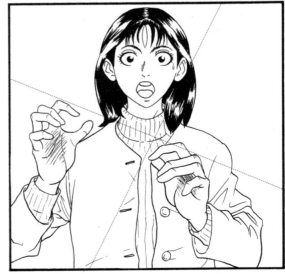

Figure 3

18

Figure 4

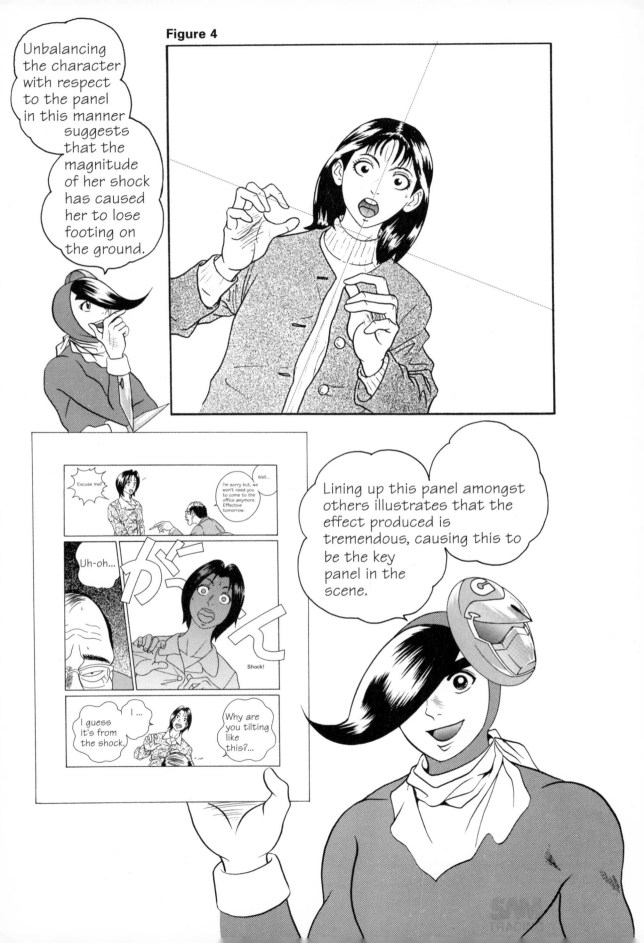

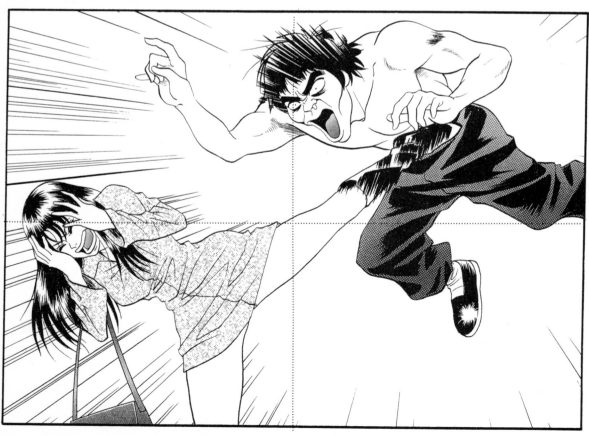

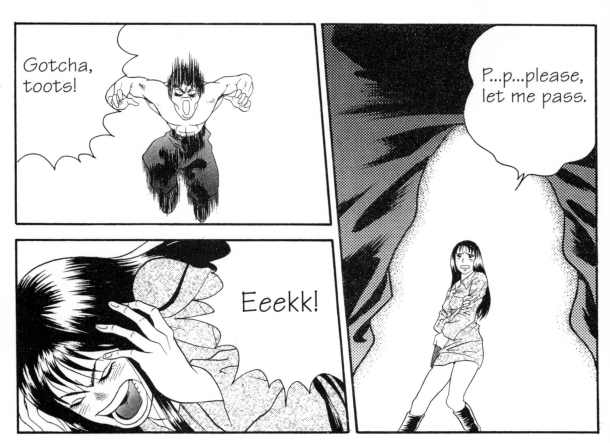

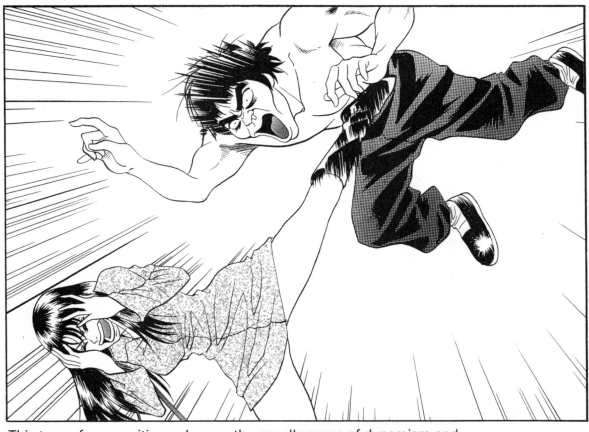

This type of composition enhances the panel's sense of dynamism and is particularly effective for action scenes.

2. A Well-planned Composition Creates Space.

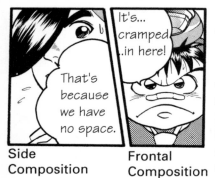

Side Composition

Frontal Composition

That's because we have no space.

It's... cramped ..in here!

In a story, the characters move about constrictedly toward the story's climax, so that the story's major objectives may be fulfilled and obstacles in their paths may be overcome. The "setting" expresses changes in the characters' movements and circumstances. This "setting" constitutes the background within which the character exists. However, this setting is not merely something added to the character's background: it must be established as a space within which the character may move about freely.

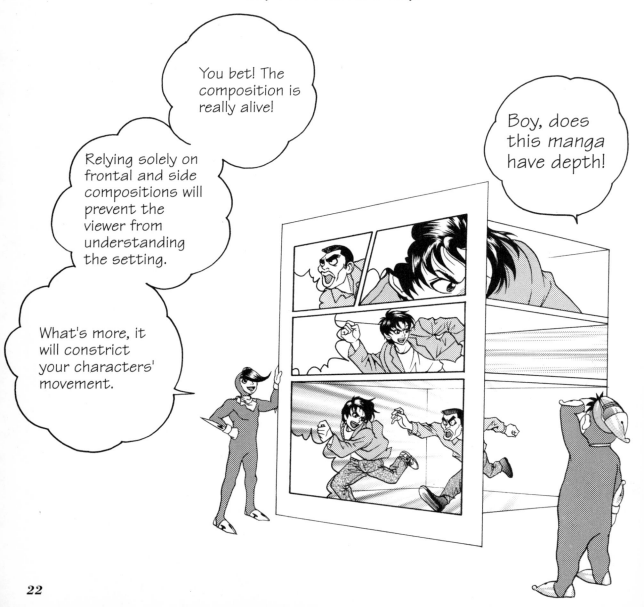

You bet! The composition is really alive!

Relying solely on frontal and side compositions will prevent the viewer from understanding the setting.

What's more, it will constrict your characters' movement.

Boy, does this *manga* have depth!

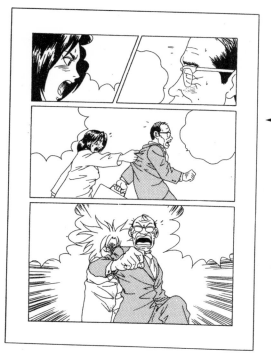

Cramped Composition

Compare the figure to the left (a cramped composition) with the one below (with space). The one below allows the characters ample room for comfortable motion within the panel.

←

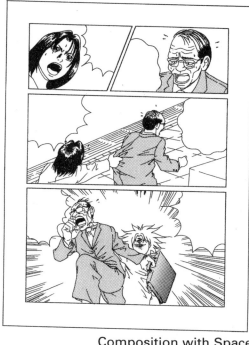

Composition with Space

So, big bro, you gotta tell me. Just how do you create space in a composition?

Well now, let's talk a little about perspective.

Creating Space in *Manga*

The laws of perspective are used to create the illusion of 3-dimensional (length + width + depth) space within a 2-dimensional (length + width) picture plane.

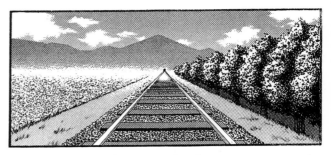

The logic behind the laws of perspective is most apparent in a train track. As the 2 rails retreat in the distance, they seem to approach one another, appearing to make contact at the very final point, known as the "vanishing point." The vanishing point is the origin for depth lines, giving the composition a sense of depth.

Manga usually employs 3 types of perspective to suggest the following space:
• 1-point perspective
• 2-point perspective
• 3-point perspective

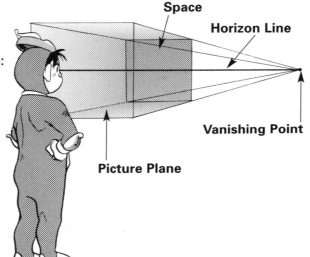

In this perspective, those objects close to the viewer appear larger and in greater detail. As the distance grows between the object and the viewer, the object appears smaller. In other words, distant points converge in the picture plane.

This final point where lines converge is called the "vanishing point." When drawing, it becomes the origins of these lines. The vanishing point is usually set somewhere along the horizon line.

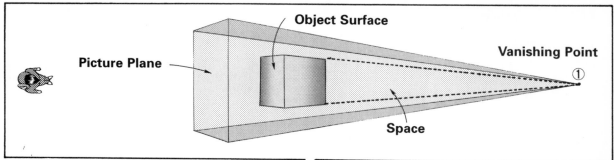

Object Surface

Picture Plane

Vanishing Point

①

Space

1-Point Perspective

Use 1-point perspective when the front of the subject is parallel to the picture plane. This is often used in general compositions depicting skylines or townscapes.

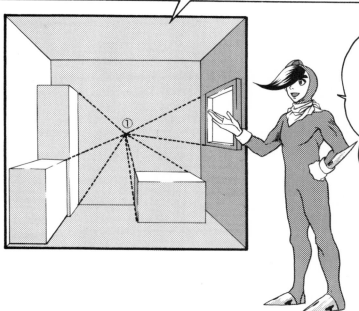

①

1-point perspective is excellent for making the lines of a room interior or corridor appear to recede straight back.

Background in 1-Point Perspective

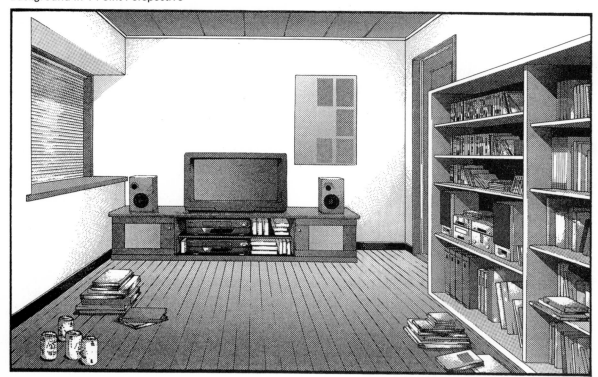

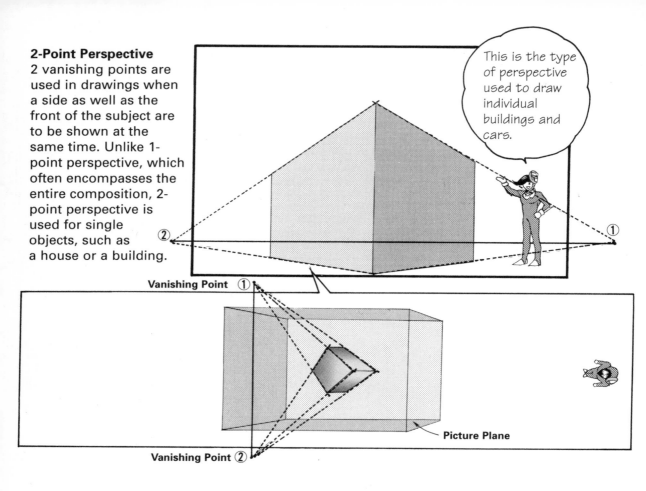

2-Point Perspective

2 vanishing points are used in drawings when a side as well as the front of the subject are to be shown at the same time. Unlike 1-point perspective, which often encompasses the entire composition, 2-point perspective is used for single objects, such as a house or a building.

This is the type of perspective used to draw individual buildings and cars.

Vanishing Point ①

Picture Plane

Vanishing Point ②

Background in 2-Point Perspective

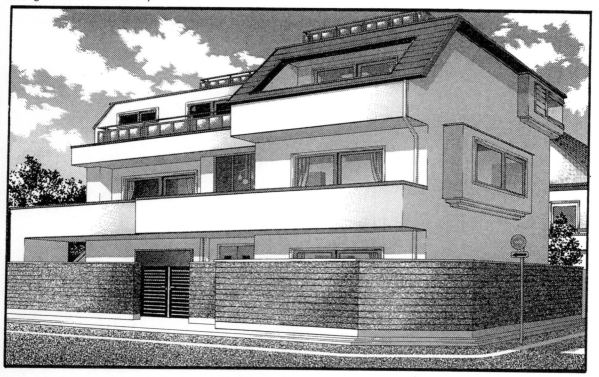

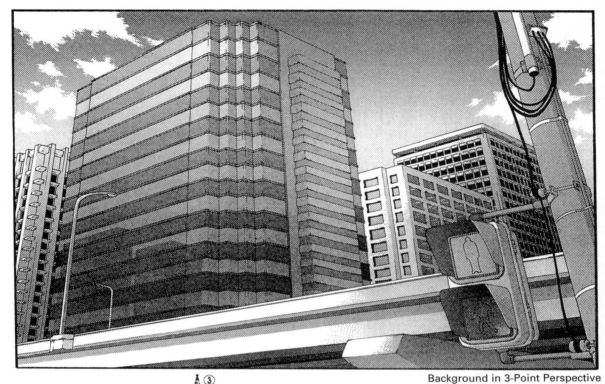

Background in 3-Point Perspective

3-Point Perspective
3 vanishing points are used when a high or low angle is to be added to a 2-point perspective, showing the front and side of the subject. 3-point perspective allows the artist to draw from a high or low angle or from a bird's eye view.

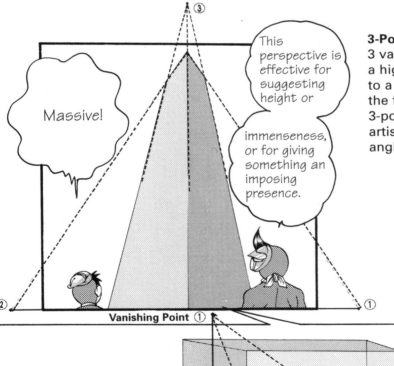

Massive!

This perspective is effective for suggesting height or

immenseness, or for giving something an imposing presence.

Vanishing Point ①

Vanishing Point ③

Vanishing Point ②

Picture Plane

Portraying High and Low Angles

Manga is typically drawn from the characters' point of view. However, it is compositionally impossible to render a fully developed *manga* from the characters' point of view alone. This bears largely on the quality of the final artwork.

Next, we'll discuss the effects produced by different angles.

The work's appeal will be lost if it is rendered entirely from the characters' point of view.

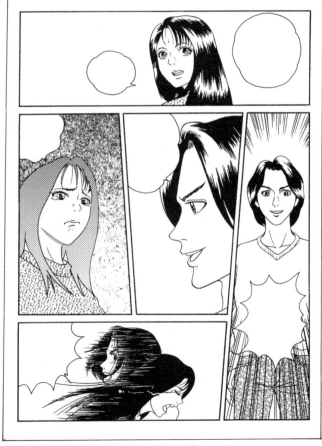

Too lame. These panels are totally redundant.

Composing the entire *manga* from the characters' point of view will result in an extremely monotonous, dull work.

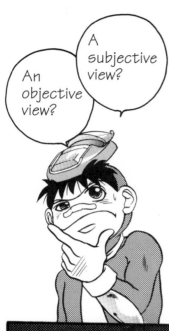

In *manga*, there are 2 overall forms of composition. The first is an objective view, allowing the reader to observe the scene from an outside perspective. The other is a subjective view where the reader shares a character's perspective, allowing an inside look at the scene. In other words, for the former, the reader assumes an aloof perspective while in the latter, the reader assumes an emotionally participating perspective.

In contrast, for the artist, an objective view is one where he or she must explain the setting, while the subjective view is one where he or she must communicate the crux of the situation.

Consequently, the artwork requires a shifting of angles, be it low or high, in order to clarify and make effective these 2 points of view.

Subjective view: Conveyed through the character's perspective

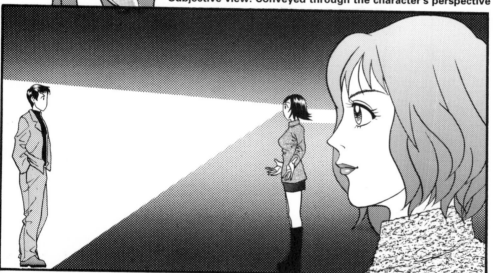

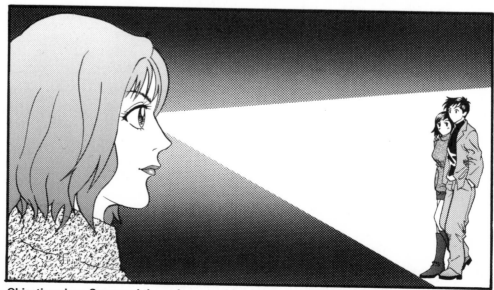

Objective view: Conveyed through an outside observer's perspective

29

Low Angles

This angle represents a clearly subjective perspective, drawing on the idea that the viewer is looking up and emphasizing size or giving the object an imposing presence.

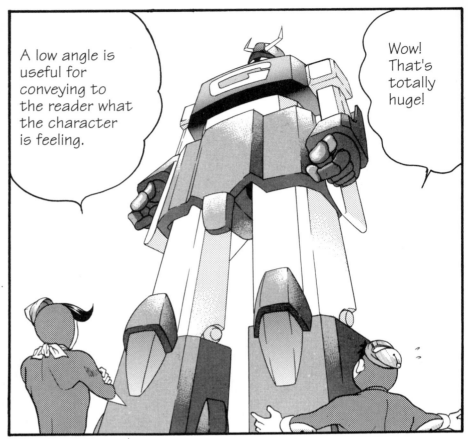

A low angle is useful for conveying to the reader what the character is feeling.

Wow! That's totally huge!

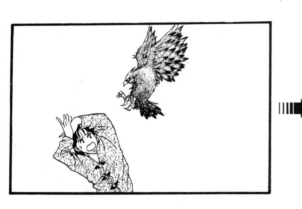

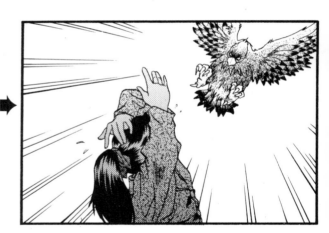

People normally react to a daunting presence coming at them from above with fearful revulsion. Using a low angle to create a "dangerous" or "terrifying" mood will make the feeling seem real.

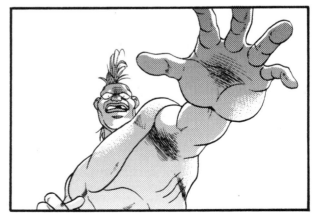

High angles

A high angle allows you to show a large area and offers consequently an objective view, effective for explaining the setting or situation.

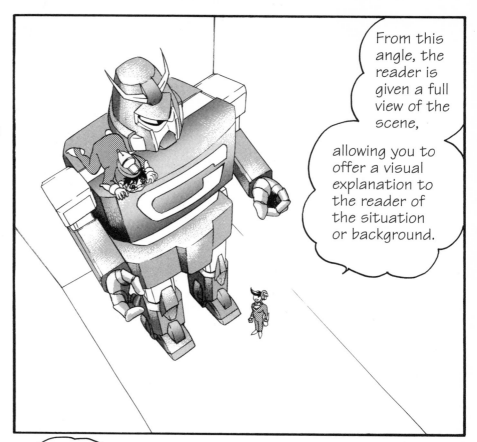

From this angle, the reader is given a full view of the scene,

allowing you to offer a visual explanation to the reader of the situation or background.

You can have a great time using perspective when you draw, provided you know how.

Wow!

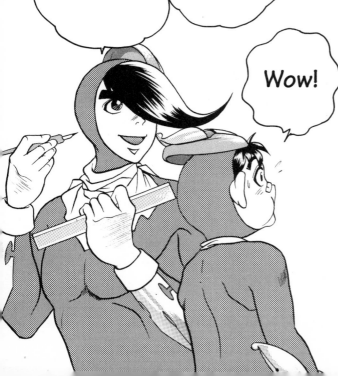

You can't get out of this one!

Using a high angle to offer a visual explanation of physical positions or the surrounding situation also clarifies how the characters are moving.

3. A Well-planned Composition Results in Skillfully Rendered Artwork.

Adding perspective is a time-consuming effort. But for today's *manga*, which demands high-quality visuals, its benefits speak loudly.

It goes without saying that you should use a straightedge for backgrounds, but it is also important that you use one rigorously when drawing cars, motorcycles and other mechanical objects. However, this does not mean that you need to use a straightedge for all objects drawn in perspective.

Characters may also be foreshortened, as with backgrounds and mechanical objects. However, unlike with backgrounds and mechanical objects, there is no call for streamlined work using a straightedge. In such cases, artists often use a wooden manikin.

Hey! Something's goofy!

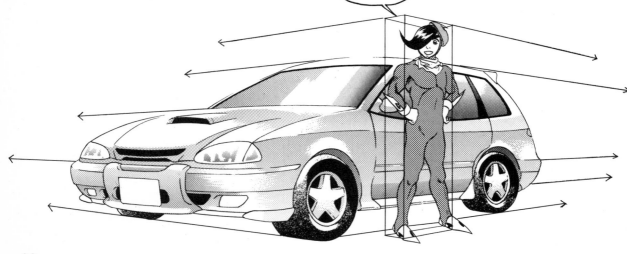

Just as foreshortening is required to draw backgrounds and mechanical objects in perspective, there are times when you will have to use foreshortening with characters.

A wooden manikin can be positioned in any number of poses and is convenient tool for beginning artists. However, there are poses impossible for the manikin, owing to its configuration. If foreshortening is to be an underlying element of your *manga*, you will find limitations in using the manikin as is. Furthermore, you will not make any progress drawing your characters by replicating the manikin.

So then, let's try imagining what the manikin looks like disassembled.

Try disassembling an actual manikin and then putting it together on paper. You will find the manikin easy to draw and that the number of movements open to your characters have expanded.

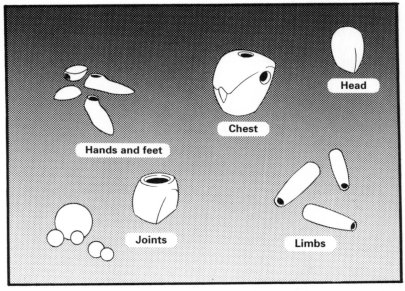

Hands and feet

Chest

Head

Joints

Limbs

The manikin's joints are spheres, while the arms and legs are cylinders. Familiarize yourself with their shapes so that you can draw them from any angle imaginable. If you then learn the proportions of the torso to the arms and the legs and the positions of the joints (which enable movement), you should be able to pose your characters properly.

33

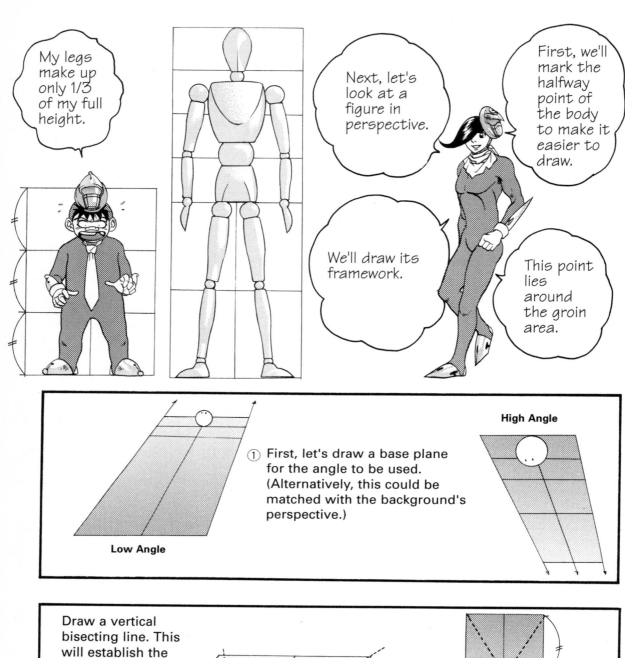

My legs make up only 1/3 of my full height.

Next, let's look at a figure in perspective.

First, we'll mark the halfway point of the body to make it easier to draw.

We'll draw its framework.

This point lies around the groin area.

High Angle

Low Angle

① First, let's draw a base plane for the angle to be used. (Alternatively, this could be matched with the background's perspective.)

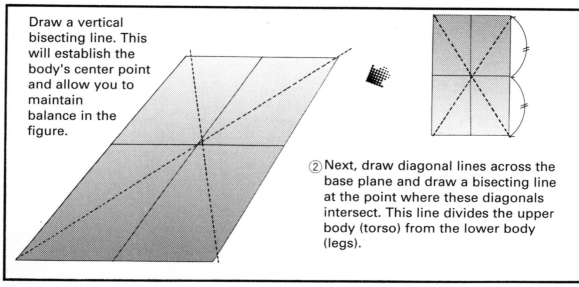

Draw a vertical bisecting line. This will establish the body's center point and allow you to maintain balance in the figure.

② Next, draw diagonal lines across the base plane and draw a bisecting line at the point where these diagonals intersect. This line divides the upper body (torso) from the lower body (legs).

③ The area above the horizontal bisecting line constitutes the groin area, so position the hip around this point.

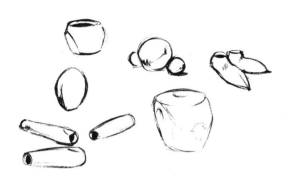

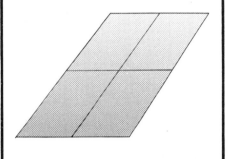

④ Assemble the manikin's parts. Maintain the image of wood in your mind as you construct the doll.

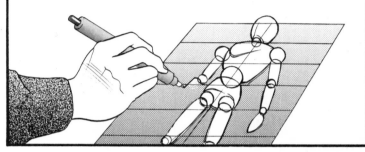

When you become accustomed to the process, you will no longer need a base plane to draw a figure.

1

3...

⑤ Once you have successfully drawn a well-proportioned manikin, flesh out the figure.

Finished!

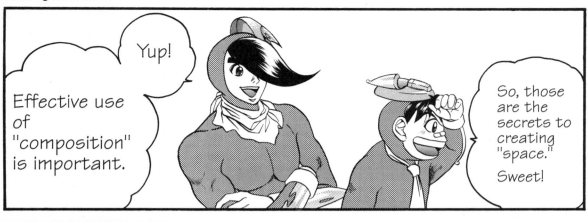

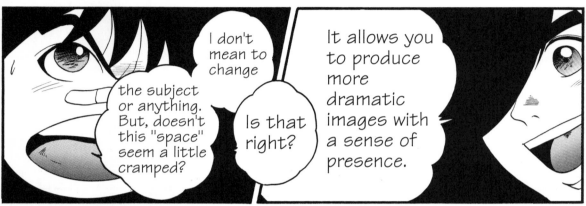

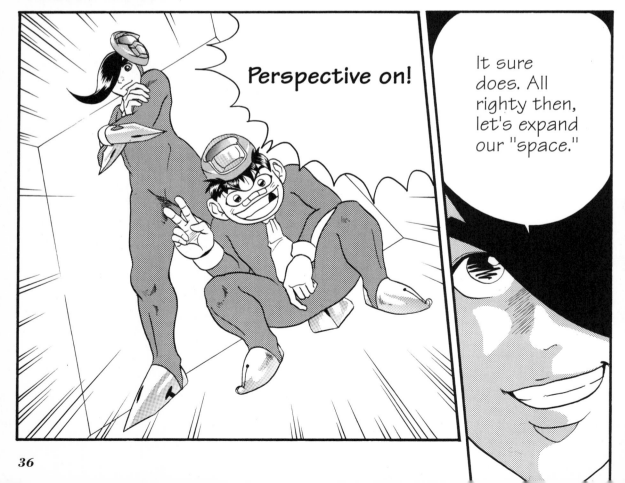

Chapter II

The Basics in Character Portrayal

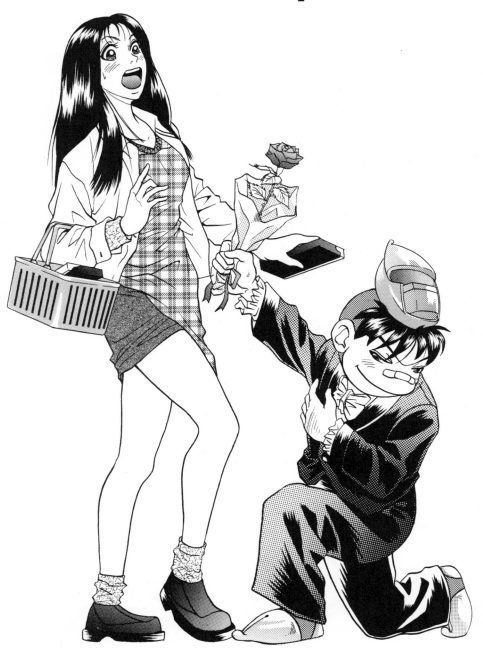

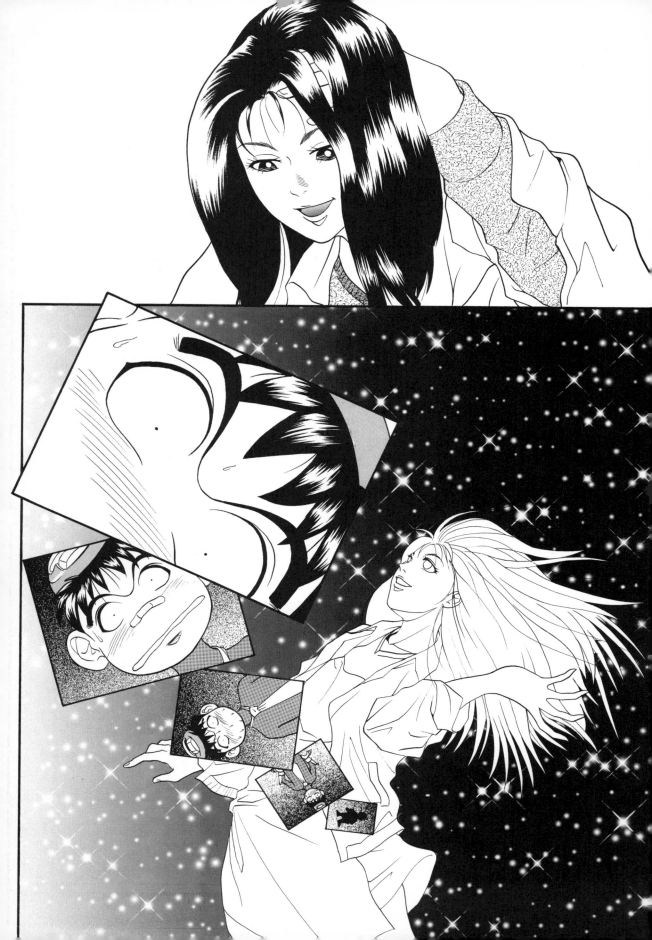

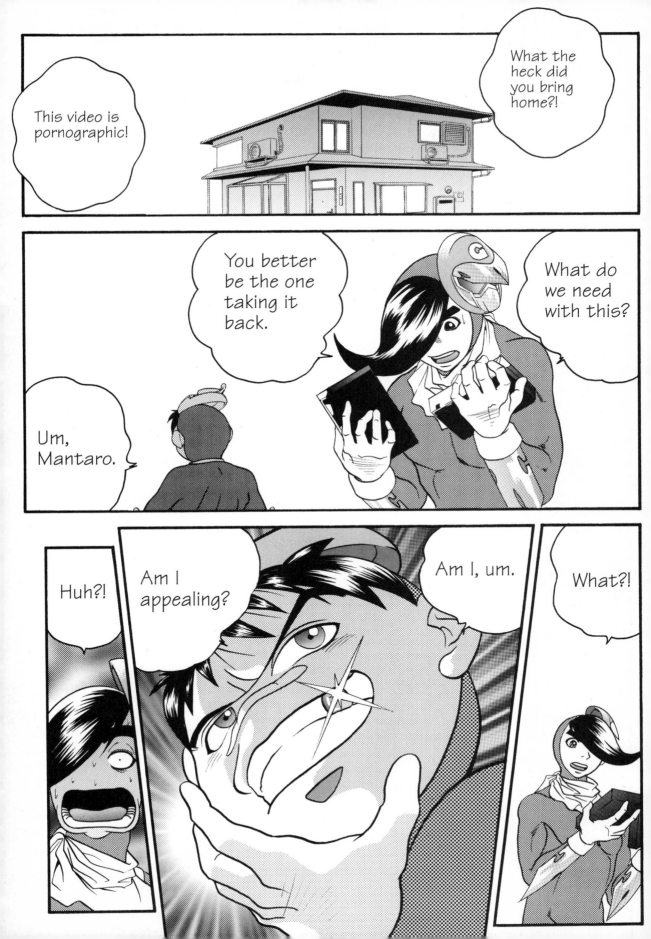

Manga artists and other connected professionals (editors, *manga* art school instructors, etc.) will often tell you that characters are the life of a *manga* work. Certainly the *manga*'s story depends on the actions of its characters. Regardless of how skillfully developed and interesting the story is, if the characters have no appeal, then the effort is a loss.

The appeal of a manga work resides in above all else, its characters!

To design a character, first you must determine his or her outward appearance. Is he handsome? Is she cute? Then you establish the personality, such as whether the character is nice or has a strong sense of justice.

Next, you develop the character's human side. He is a sucker for (\underline{X}). She just can't stand (\underline{Y}). Giving the character unexpected weaknesses will help you design a character with appeal.

Still, there are limits to how appealing you can make a character relying on the character design alone. No matter how catchy the character's lines, exciting plot development still requires that the character be sufficiently expressive.

Compare this for example with an actor who delivers his lines without performing. In other words, a character is like an actor. As a consequence, it is vital to the *manga* work that the artist assume the role of director and direct the characters' performances.

1. Exaggerating Features: Rounded Forms

Manga originates from the artistic distorting and abstracting of figures. Such distortion gives the characters their "appeal," which translates into the characters' "individuality." Thus, I feel I am not exaggerating to say that artistic distortion gives the characters their pizzazz. The most important thing when distorting a figure is to maintain balance.

Being familiar with the correct proportions is fundamental to distortion and will be the decisive factor in your success.

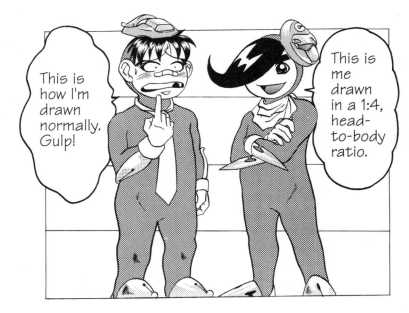

The artistic style or genre of the work determines the head-to-body ratio of the character. Make sure you are familiar with the correct proportions and maintain balance when exaggerating features to create appealing characters.

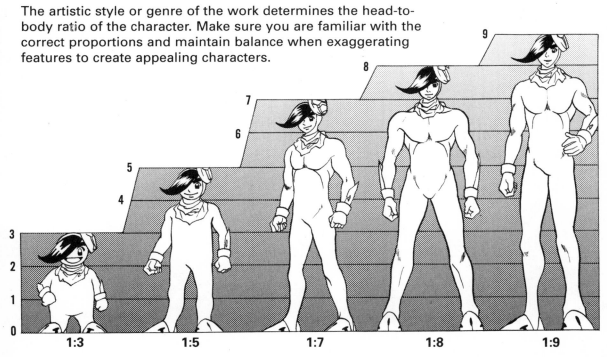

Use a cylinder to assess how much a figure should be exaggerated. When you distort the figure vertically (decrease the head-to-body ratio), fatten the character to balance out the figure.

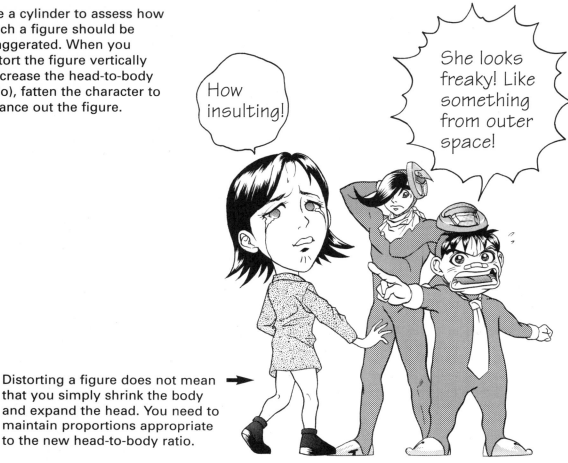

Distorting a figure does not mean that you simply shrink the body and expand the head. You need to maintain proportions appropriate to the new head-to-body ratio.

Head-to-Body Ratios

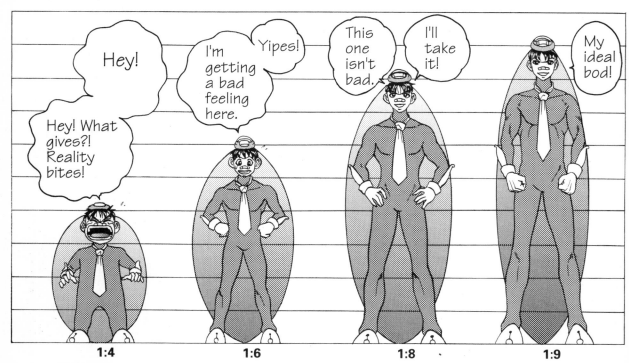

The more proportions are distorted, the rounder the figure becomes.

This is a key point in abbreviating characters as well. As the figure becomes more and more distorted, the character appears increasingly babyish.

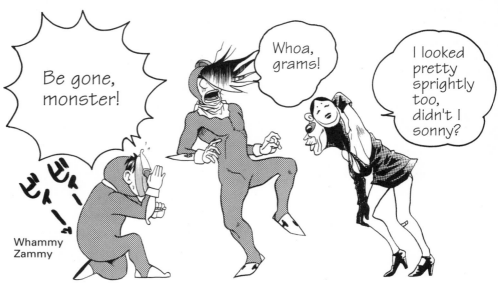

Be gone, monster!

Whammy Zammy

Whoa, grams!

I looked pretty sprightly too, didn't I sonny?

The atmosphere projected by the character varies greatly according to her head-to-body ratio.

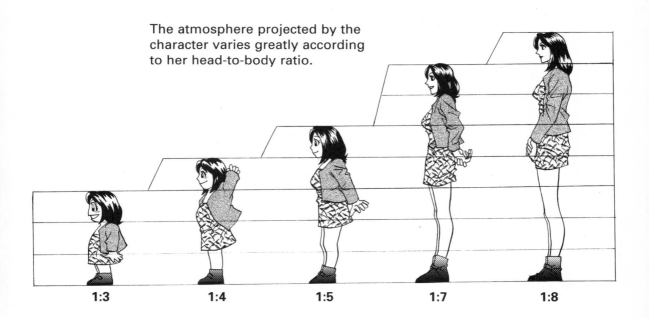

1:3　　　　1:4　　　　1:5　　　　1:7　　　　1:8

The shorter you make your character, the more you should abstract and abbreviate his or her features.

2. The Eyes Speak More Than the Mouth.

People say that the eyes are the windows of the soul, and indeed they speak as much as the mouth. Recognizing the truth of this saying, you, the artist, can indicate the emotions, feelings, or opinions of a character without relying on spoken lines. Using the eyes as a means of expression allows you to create highly dramatic scenes. In particular, the eyes speak more eloquently when conveying a character's emotions or discord between characters better than having the character express him or herself through a dialogue or a monologue.

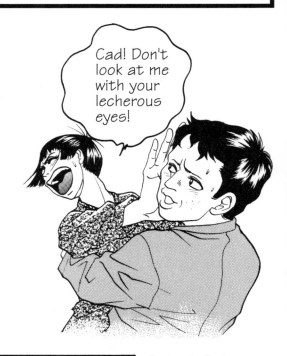

Wailing
There are no particular limits to emotions; however, this one does express the character's emotional state more directly than others.

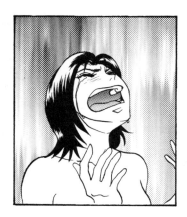

Crying in Sadness
This is the most common form of crying used. Draw the eyes cast downward: the key is to draw them as if looking at something.

Crying in Joy
While the eyes here are made to appear happy, they are also drawn to look soft.

Crying in Anger
For this, have the eyes look up and draw the lower eyelid with a slight upward curve.

As is obvious from the above examples, there are many ways to express different emotional acts, in this case "crying." This is because the eyes provide a subtle means of expression that form the kernel of the emotion, giving it further depth.

The Spectrum of Emotions Expressed through the Eyes

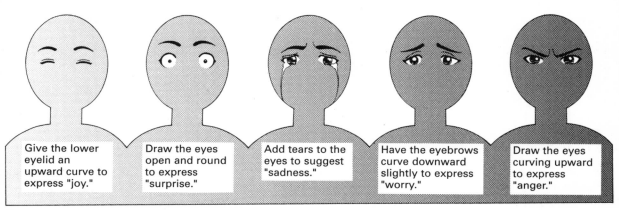

Give the lower eyelid an upward curve to express "joy."

Draw the eyes open and round to express "surprise."

Add tears to the eyes to suggest "sadness."

Have the eyebrows curve downward slightly to express "worry."

Draw the eyes curving upward to express "anger."

⬆ Emotions can be expressed clearly simply by changing the shapes of the eyes (including the eyebrows).

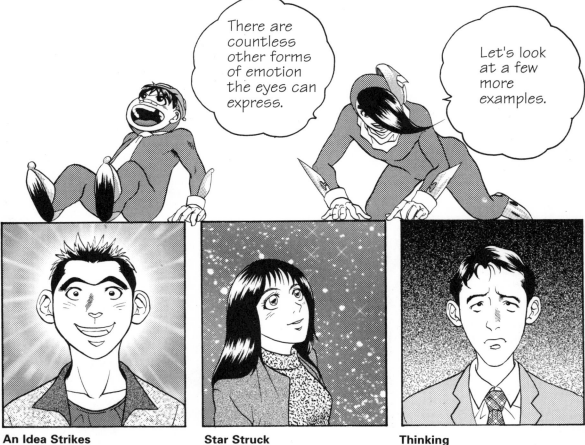

There are countless other forms of emotion the eyes can express.

Let's look at a few more examples.

An Idea Strikes
This is akin to expressions of shock. The eyes are wide open and the gaze is fixed.

Star Struck
As with "thinking," the gaze is directed upward. However, draw the eyes as if directed toward the sky rather than introspective. The key is to give the eyes a twinkle.

Thinking
Although the gaze is physically directed upward, they should be drawn as if not looking at anything in particular, but rather as if the character is visualizing something in his head. Therefore, this expression suggests that the eyes are seeing something inside the character's mind.

Flirtatious Gaze
This is basically a sidelong glance. The key to drawing this look is to lower the eyelids and to cast the gaze to the side, creating a very provocative image. Quite a languid expression, isn't it?

On Edge
Like the face suggesting when "an idea strikes," this too is analogous to expressions of "shock." The distinguishing feature of this expression is that the multiple eye contours suggest simultaneously shock and anxiety.

Eyes Averted
People tend to avoid eye contact when they lie or do not feel confident. However, the alternative interpretation of averting the eyes is that the character is timid or innocent.

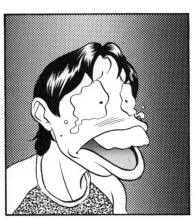

Distorted Face
While this cannot be used in serious scenes, exaggerating facial features strongly conveys emotions. Please note that you should be selective in the character you use.

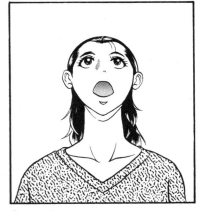

Spaced out
Suggest a dazed, woozy look by not fixing the gaze on anything in particular. The key here is to widen the distance between the irises slightly and to show full white reflections in the irises.

The Glare
Wrinkles form between the eyebrows, and the gaze is given definite direction. More force can be achieved by drawing the eyes rolled slightly upward. Keep the irises small for more effect.

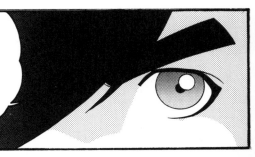

So, you see the eye takes on distinctive shapes to express different emotions.

Study carefully what particular aspects form the "kernel" of these emotional expressions.

3. Contrasting the Eyes and the Mouth to Reveal Emotion

Like the eyes, the mouth constitutes a key feature in facial expressions. The mouth works in conjunction with the eyes to suggest a firmly convincing expression.

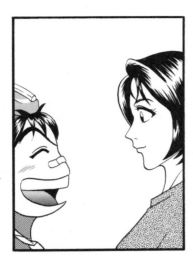

However, occasionally the mouth and eyes express contradicting emotions. A concrete example is a fake smile.

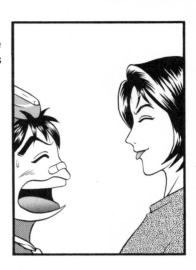

Using a different mouth with the same eyes can express an entirely different emotion.

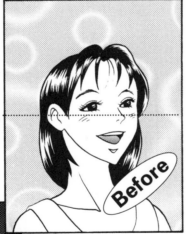

Before

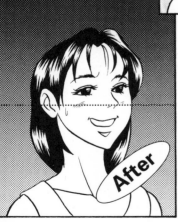

After

The eyes are smiling, yet the mouth is turned down. Clearly the eyes and mouth are expressing 2 contradictory emotions. However, the interesting point is not only that the 2 contradicting features can express a legitimate emotion, but also that complex, subtle emotions can be expressed simply by contrasting the eyes and the mouth. Using this can allow you to separate emotions truly felt from false fronts displayed for others, thus taking your character's appeal to that extra level.

There ain't nuthin fake about her radiant smile!!

Glaring

Wailing

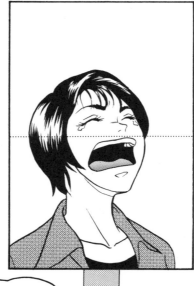

Angry

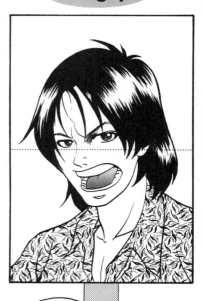

Whoa!

Contrasting the emotions in the eyes and the mouth widens the variety of expression available to you.

This applies to expressions other than a fake smile as well.

Variation

Feeling Impatient

Variation

Guffawing

Variation

Grinning and Bearing It

Practicing Facial Expressions

Laughing

Short "a"

Long "e"

Long "oo"

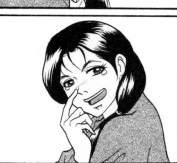

Short "e"

Long "o"

The vowels a, e, i, o, u, form the base of most speech.

Drawing faces articulating the various vowels is an effective means of practicing different facial expressions.

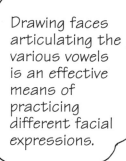

Surprised/Fearful Crying Angry

52

Short "a"

Long "e"

Long "oo"

Short "e"

Long "o"

Different characters may have vastly dissimilar ways of expressing the same emotion, such as "pain."

Therefore, I recommend that you practice drawing a variety of characters articulating an assortment of vowel sounds.

4. Giving the Readers a Sizzling Glance

Normally in manga, the character's gaze is directed toward an object or another character. But what happens when the artist makes a point of directing the character's gaze toward the reader, who is not participating in the story?

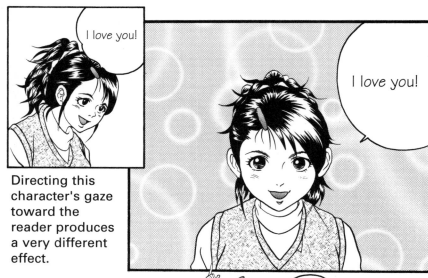

Directing this character's gaze toward the reader produces a very different effect.

I love you!

I love you!

Hey!

That's intense, big bro'!

See, what I mean? For some reason, the character's feelings are conveyed more keenly.

This is caused, because the reader, who is indirectly participating in the story, is following the plot when the character's emotions are transferred to him or her, resulting in the character accepting the emotions as a natural effect. Consequently, directing a character's gaze toward the reader when delivering a key line will cause the reader to have a more intense reaction.

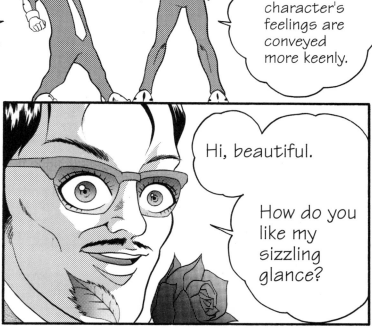

Hi, beautiful.

How do you like my sizzling glance?

← Read right to left

Um, excuse me.

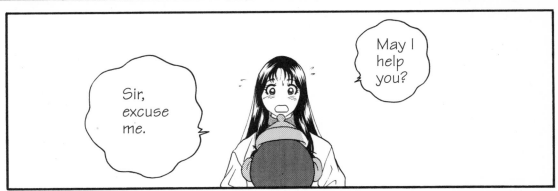

May I help you?

Sir, excuse me.

Hello.

Do you need help, sir?

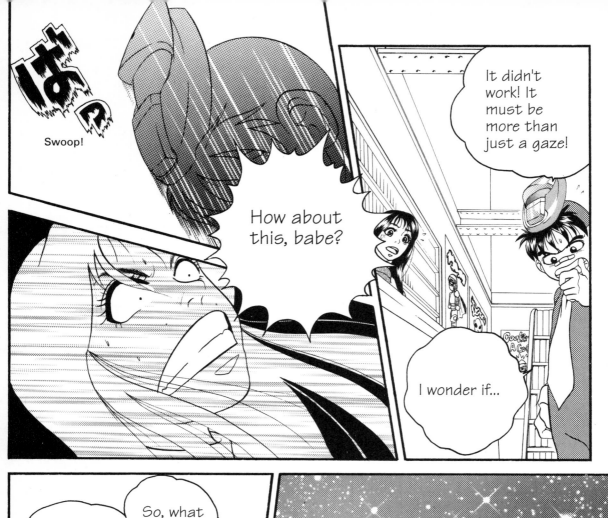

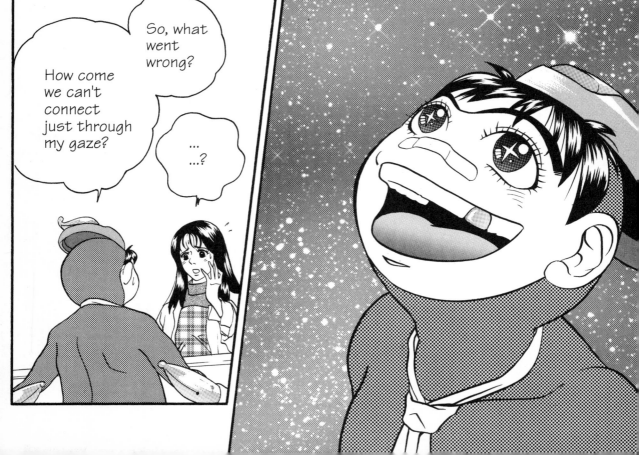

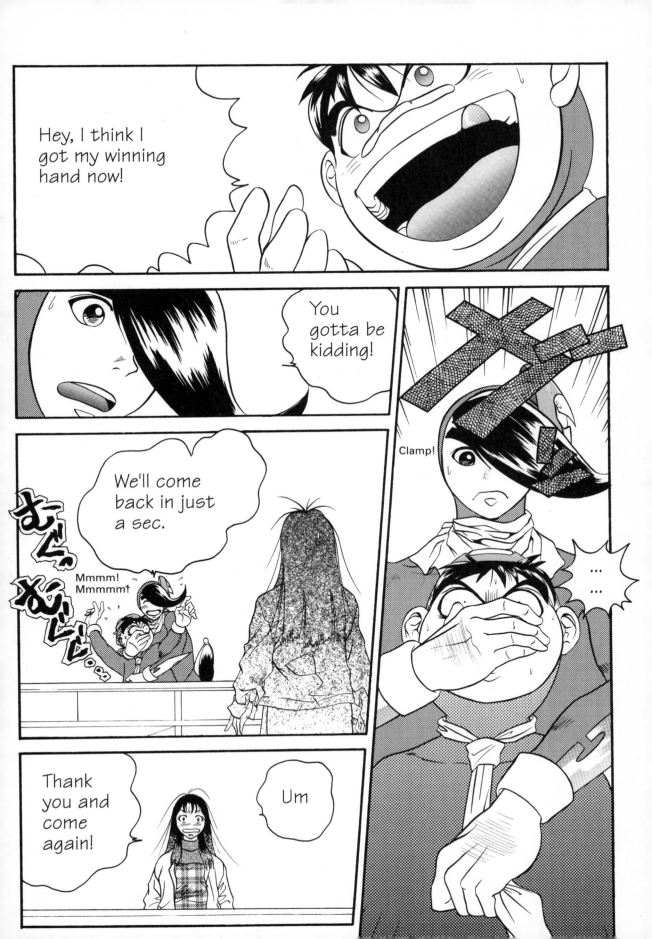

Why'd you go and mess things up?

She was mine, man!

You're just a customer. You're not her friend.

So what the heck am I supposed to do?

But, I'm always there renting videos!

Look...

That girl doesn't know the first thing about you. And then you go and stare at her!

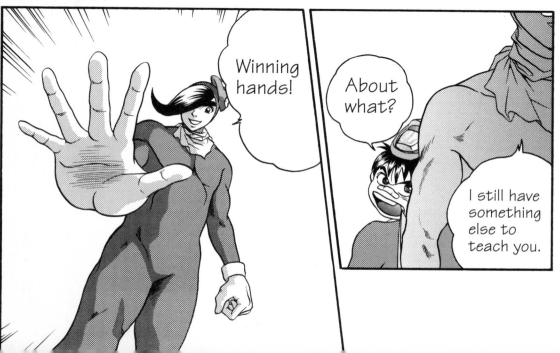

Winning hands!

About what?

I still have something else to teach you.

5. Winning Hands

Hands hold objects, throw punches, and give the character freedom in movement. But, is it acceptable to use the hands solely for actions?

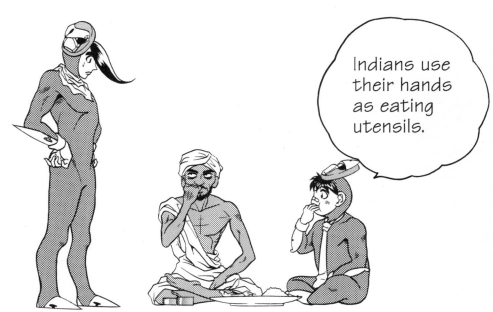

Indians use their hands as eating utensils.

The hands are used in films, and in particular we see hands expressing such reactions as "You got me there!" or "How the heck should I know?" in movies from the United States.

While these gestures may seem alien to the Japanese, they are recognized as a means of expression. Thus, hands cannot only be used in direct actions, but also as a means of expression containing subtle significance.

The hands are expressive props!

Adding hands to the sample expressions shown in section 2 (p. 46) makes the situation expressed in the image all the more convincing.

Make good use of hands to communicate emotional states!

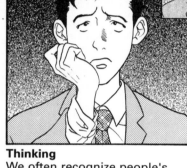

Thinking
We often recognize people's behavior or actions without analyzing them logically. Resting the chin on a hand is a standard pose expressing "thinking."

Flirtatious Gaze
Having the fingers brush against the lips portrays the character provocatively, enhancing the seductive nature of the image.

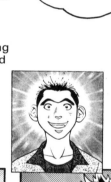

An Idea Strikes
The shift from elation in having solved a difficult problem to determination in seeing it through is expressed by the one hand striking the other.

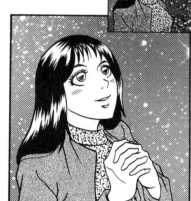

Star Struck
The desire to become closer to that love interest is expressed through the clasped hands.

Communicating through the Hands

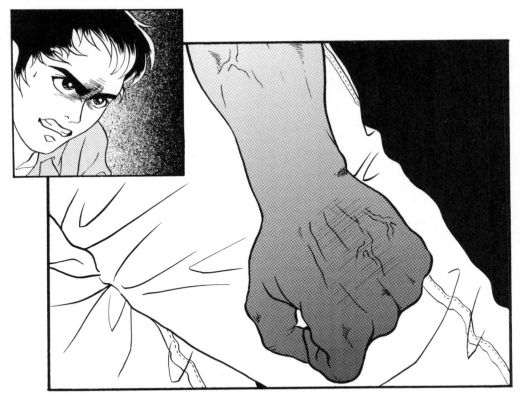

This clenched fist effectively illustrates that the character is restraining his anger.

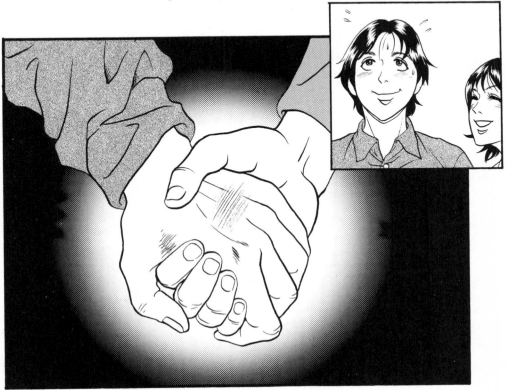

The feelings of this timid boyfriend for his girlfriend are revealed as he openly holds her hand.

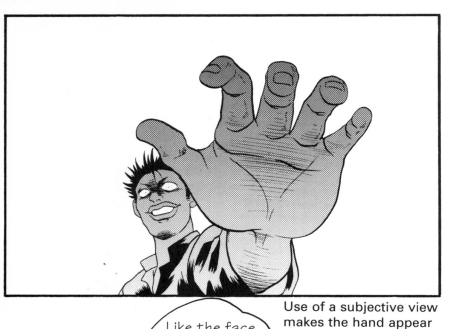

Use of a subjective view makes the hand appear intimidating.

Like the face, the hands are also able to express emotions.

Making good use of the hands will allow you to communicate more than with the face alone.

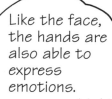

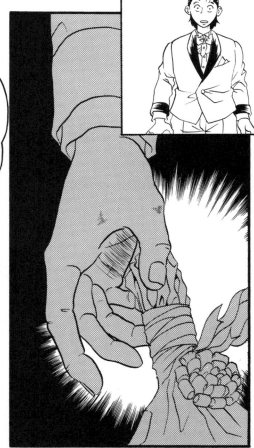

Showing the hand become so limp that it drops what it was holding is a silent way of expressing the impact of shock. In a certain sense, this technique is even more effective than relying on facial expressions.

Using the Hands to Portray the Character

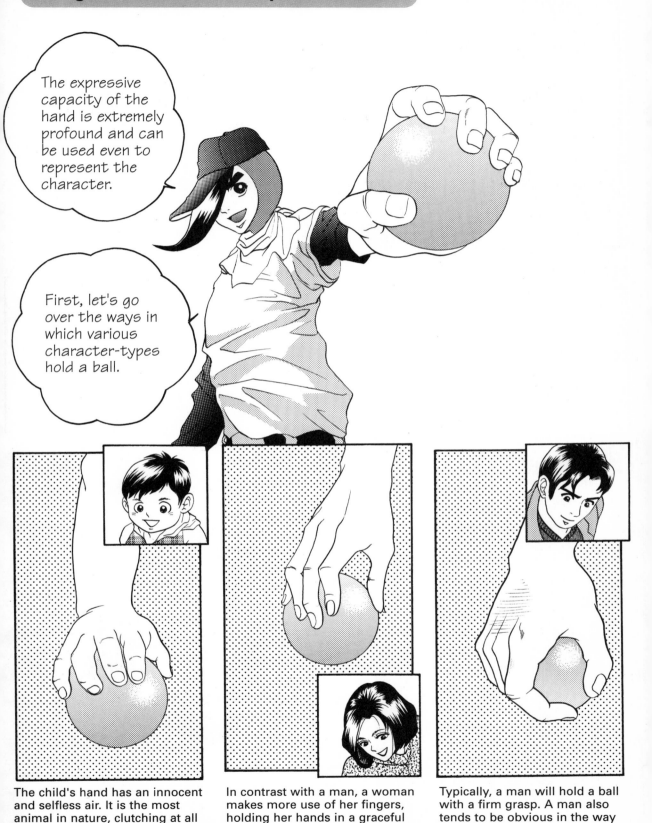

The expressive capacity of the hand is extremely profound and can be used even to represent the character.

First, let's go over the ways in which various character-types hold a ball.

The child's hand has an innocent and selfless air. It is the most animal in nature, clutching at all objects, regardless of their size, with a birdlike grasp.

In contrast with a man, a woman makes more use of her fingers, holding her hands in a graceful manner. This represents the feminine nature of the character.

Typically, a man will hold a ball with a firm grasp. A man also tends to be obvious in the way he uses his hands.

Showing a character raising her finger when laughing is going a bit overboard with feminine gestures and paints the character as pretentious. A rich, older woman is a prime candidate for using this.

➡

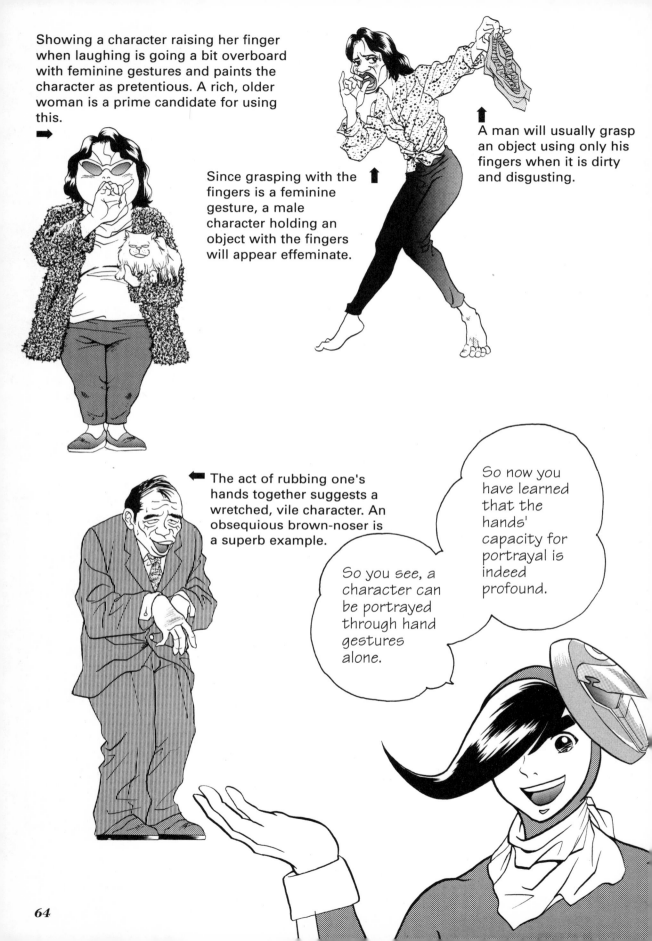

A man will usually grasp an object using only his fingers when it is dirty and disgusting.

Since grasping with the fingers is a feminine gesture, a male character holding an object with the fingers will appear effeminate.

The act of rubbing one's hands together suggests a wretched, vile character. An obsequious brown-noser is a superb example.

So now you have learned that the hands' capacity for portrayal is indeed profound.

So you see, a character can be portrayed through hand gestures alone.

6. Charming Idiosyncrasies

Once you have delved deeply into how to make your character appealing, you will need to develop his or her "peculiarities" in concrete terms.

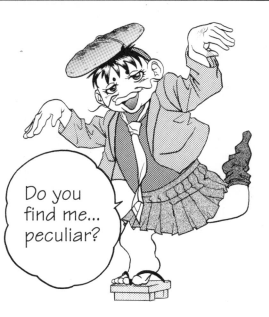

Do you find me... peculiar?

Having your character display bizarre behavior or engaging in joking acts is a means of emphasizing his or her "peculiarities." However, this will restrict the character's personality-type, and making the effort to emphasize a character's peculiarities in a short manga, with its limited format, is next to impossible. Therefore, let's take a look at a few of the most natural, unaffected habits that people have.

Assorted Habits

Depending on the particular habit, there may be many others who engage in the same act, or it may be something easily overlooked. Yet, drawing attention to these habits in your panels can result in your character projecting even more appeal. This is because the motives behind these habits are familiar and understandable. These motives are extremely useful for making the character seem convincing. Try observing the habits of your family members and friends for reference. Character design is loads of fun!

Nose Picking

Hair Twirling

Finger Chewing

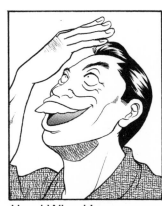

Head Whacking

The Impact of Habits

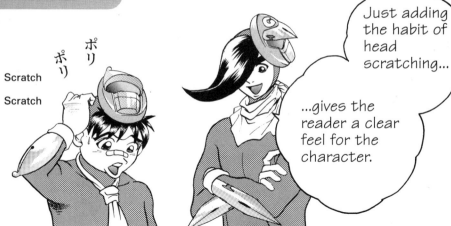

The panels on the next page are a reproduction of those on this page, but composed to include a close-up of a habit of a character making his first appearance in this scene.

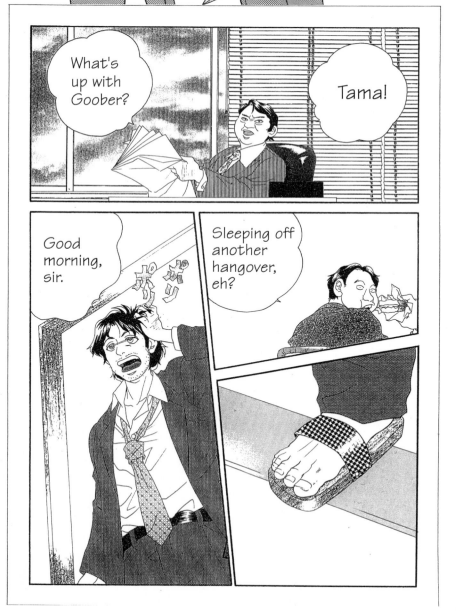

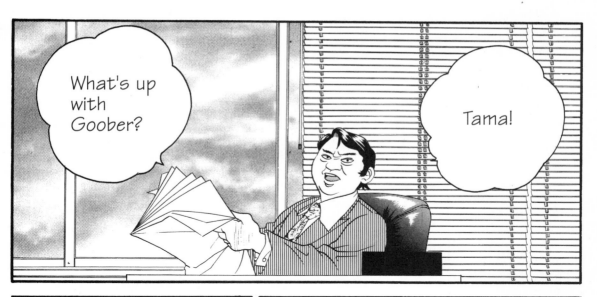

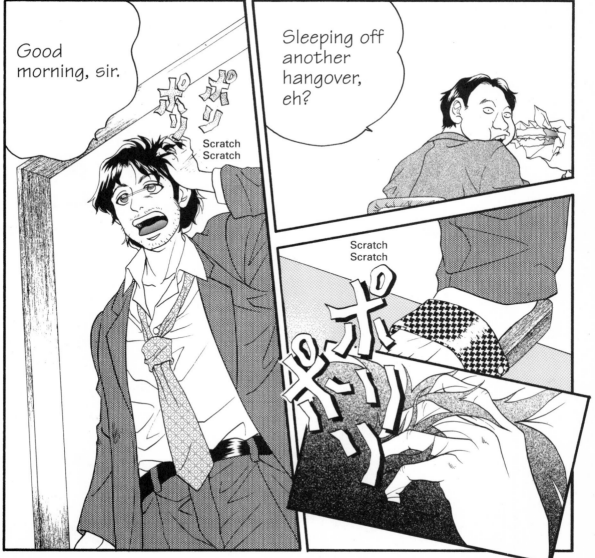

Using a Habit to Design a Character

Habits offer a clear definition of the character, or rather his or her personality, by exhibiting patterned behavior.

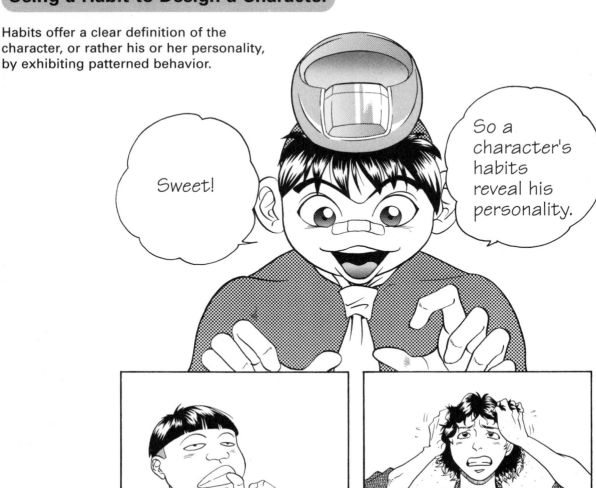

Sweet!

So a character's habits reveal his personality.

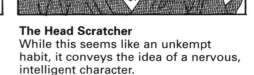

The Nail Biter
This is a disgusting habit. Characters who stick their fingers in their mouth usually lack a sense of independence and tend to be emotionally reliant on others.

The Head Scratcher
While this seems like an unkempt habit, it conveys the idea of a nervous, intelligent character.

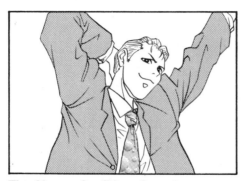

The Always-Confident Stretcher
This seemingly narcissistic, overly self-conscious character is actually the most commonly misunderstood, and his kind efforts go unthanked.

The Finger Drummer
As is obvious just by looking, this is a short-tempered character.

Using Body Types and Props to Design a Character

The Sweat Mopper
This character at first glance appears to be nothing more than a dimwit, but this guy is really just timid, and would never tell a lie. He is definitely deserving of trust.

The Sniffer
This habit clearly reveals a nervous character, who is constantly on guard.

The Constant Comber
In a word, this is a poser. He is overly confident and is an active character, not afraid of anything.

The Nose Wiper
This habit is indicative of a childish nature and defines this character as a little impish and wild.

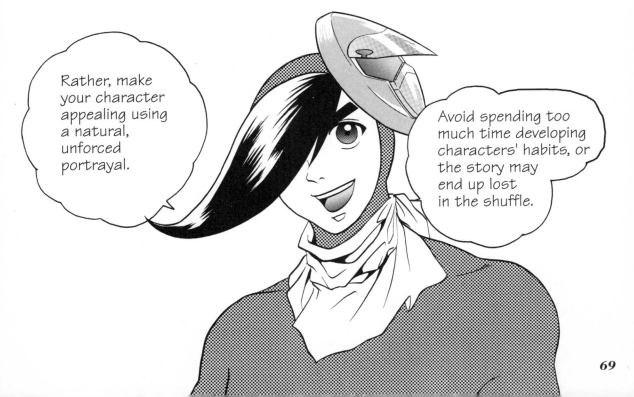

Rather, make your character appealing using a natural, unforced portrayal.

Avoid spending too much time developing characters' habits, or the story may end up lost in the shuffle.

7. Using Close-ups to Increase Impact

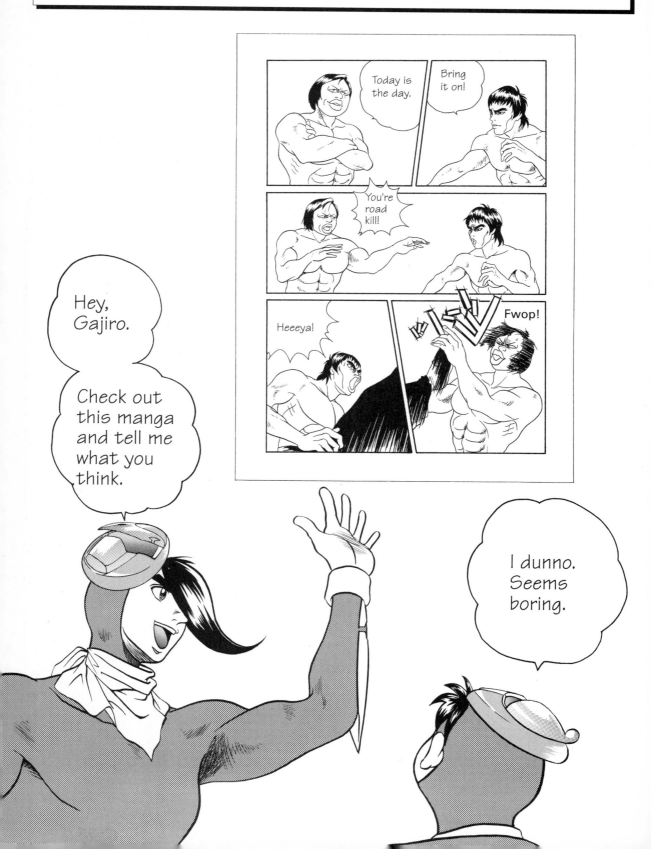

The figure on the preceding page is a common layout used by beginners in their final copy. The fixed composition makes the panels appear tidy but boring. The artist has unconsciously drawn the characters from the easiest angle, ensuring consistency in the characters' heights.

You know...

(Gulp) Absolutely!

Appealing manga is not composed from a single perspective.

To prevent your compositions from becoming monotonous, try using long shots, medium shots, and close-ups. Effective use of these composition ranges will give variety to your compositions and give your readers incentive to read!

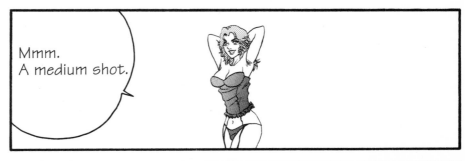

Mmm. A medium shot.

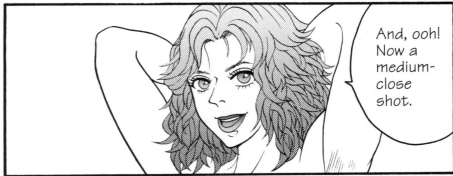

And, ooh! Now a medium-close shot.

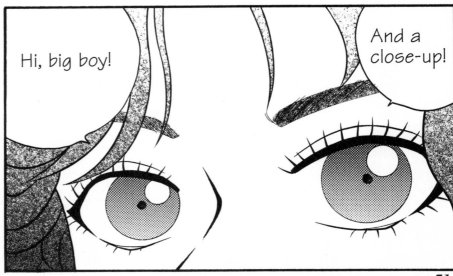

Hi, big boy!

And a close-up!

The Expressiveness of Close-ups

Close-ups of the Eyes
The eyes' openly expressive nature makes close-ups of them extremely effective.

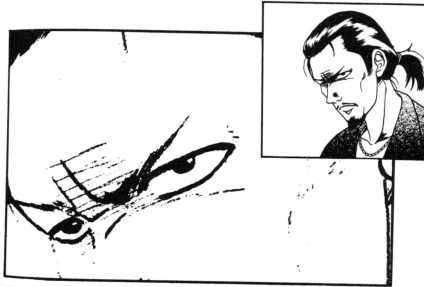

The Glare
This brings out the potency of the glare full force, allowing the artist to portray the sense of tension in the scene effectively.

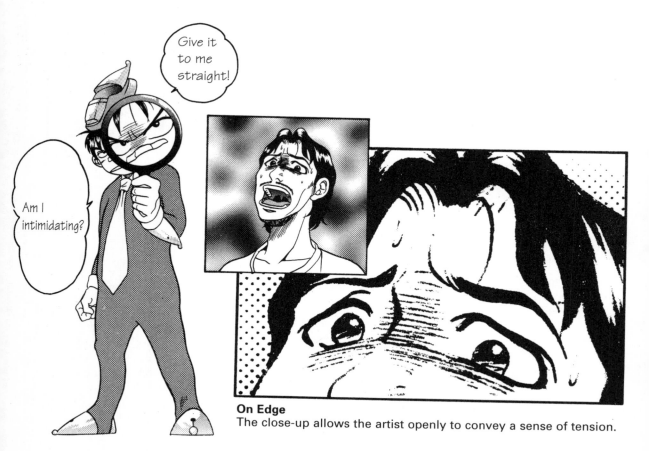

On Edge
The close-up allows the artist openly to convey a sense of tension.

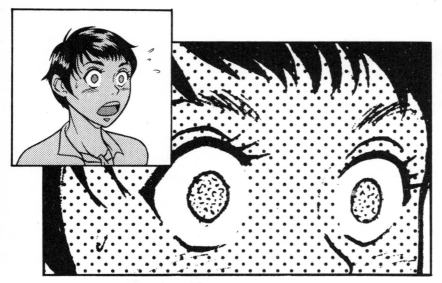

Surprise/Shock
Here, the close-up enhances the sense of shock, allowing anticipation of the plot's development.

The Smirk
A medium-close shot gives the impression of a common leer, but the close-up gives off a creepiness, lending the image an uncomfortable, even threatening air.

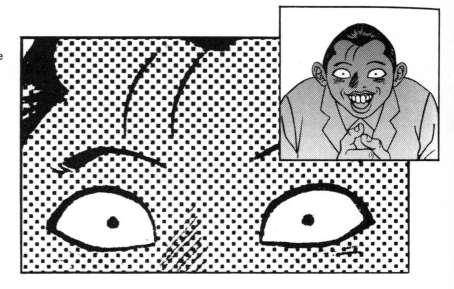

The Gaze
A close-up of eyes gazing at something with interest allows the reader to entertain different expectations, depending on the particular situation. Perhaps this character is only responding to the interested glance of another character. Our human nature produces the effect of this shot.

Close-ups of the Mouth

In contrast with the eyes' openly expressive
nature, the mouth allows for subtlety.

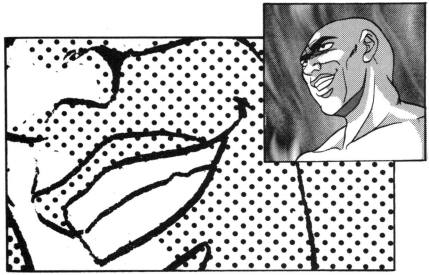

The Smirk

While the mouth is essentially smiling, the close-up suggests a
subtly different sense, offering a dark portent of things to come.

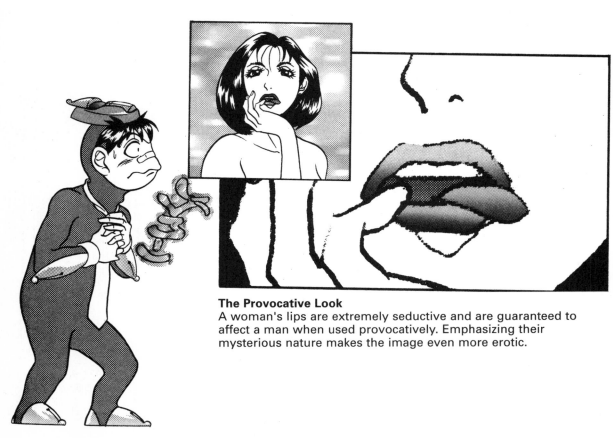

The Provocative Look

A woman's lips are extremely seductive and are guaranteed to
affect a man when used provocatively. Emphasizing their
mysterious nature makes the image even more erotic.

Close-ups of the Hands and Feet

While we demonstrated the expressive capacity of the hands earlier in section [5], the feet really are lacking in expressiveness and do not add much to dramatic portrayal. However, there are occasions when the feet can be unexpectedly expressive.

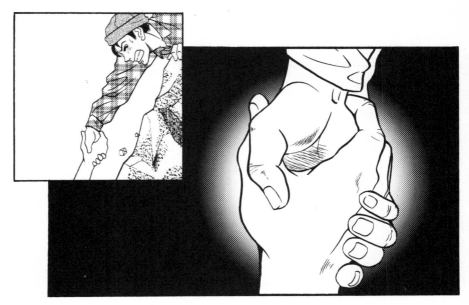

Heaving up

Scenes where a character about to fall from a cliff is being rescued by another character make frequent appearances on TV dramas and other shows. Close-ups are extremely effective here as well, because the fate of the two rest in these hands, causing the sense of tension to be compounded. In *manga*, artistic license does not stop here, and the key details are normally enlarged.

The following pages show sample effects applied to manga.

Check it out!

Don't go away!

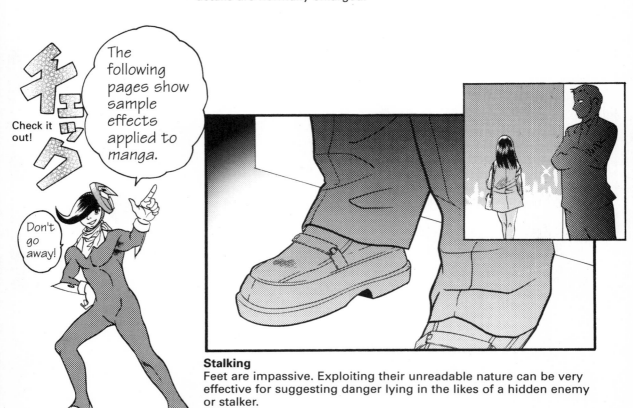

Stalking

Feet are impassive. Exploiting their unreadable nature can be very effective for suggesting danger lying in the likes of a hidden enemy or stalker.

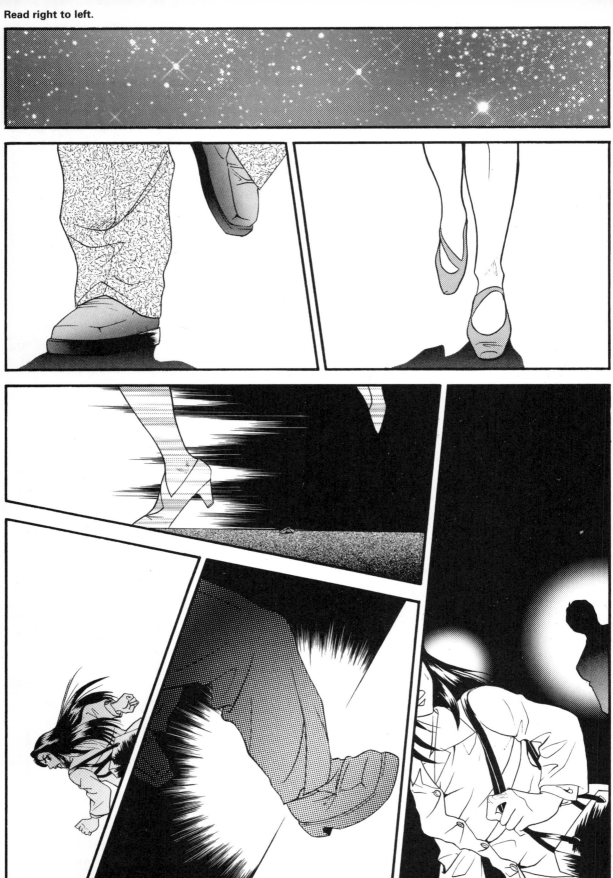

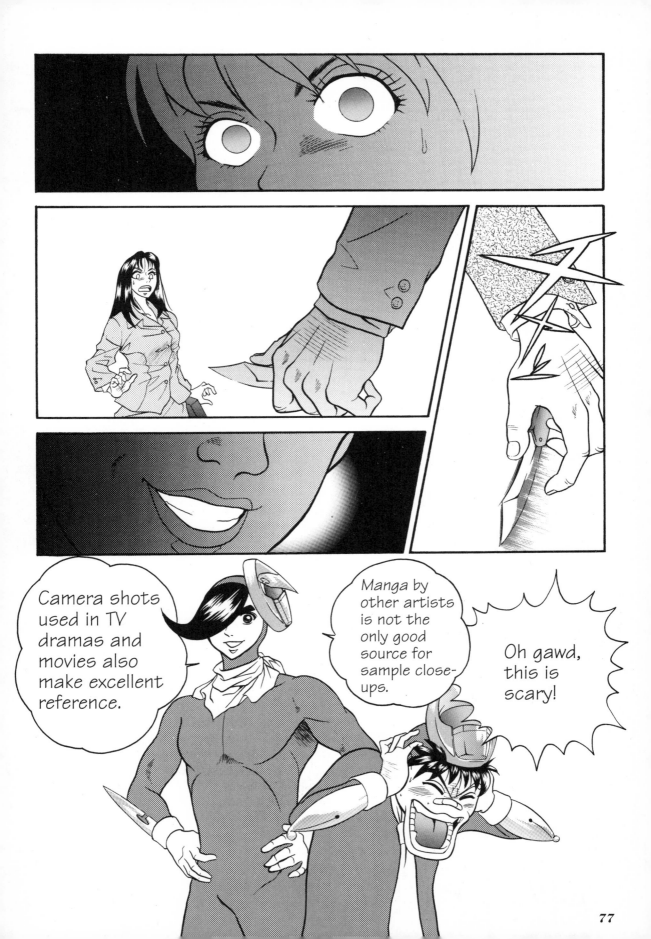

Camera shots used in TV dramas and movies also make excellent reference.

Manga by other artists is not the only good source for sample close-ups.

Oh gawd, this is scary!

8. Exaggerate and Make It Fly!

Read right to left.

78

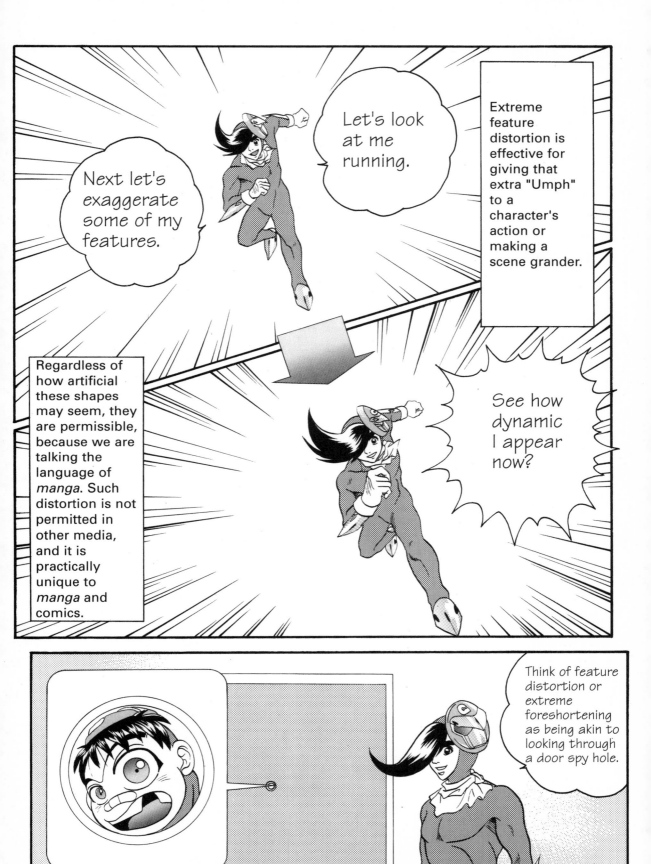

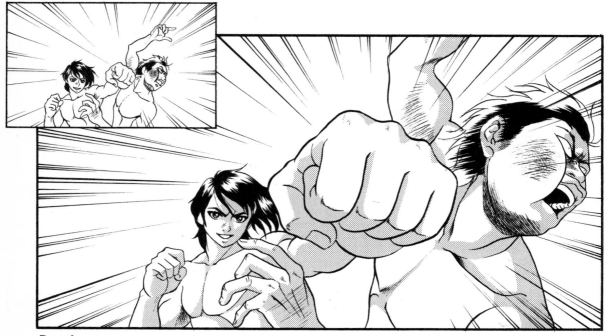

Punch

Exaggerating the size of the fist enhances the visual force of the composition, suggesting the effective demolishment delivered.

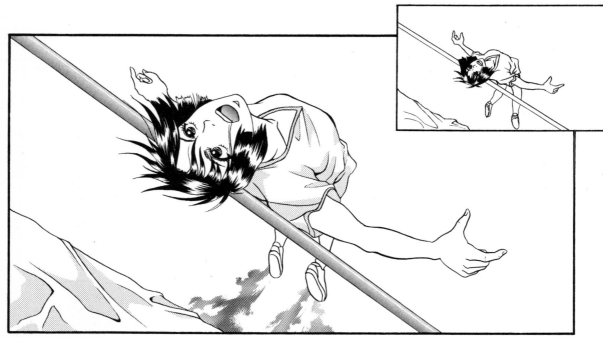

Jump

The contrast between the upper and lower half of the figure portrays visual dynamism, giving the image a sense of reality not afforded by a more realistic rendering.

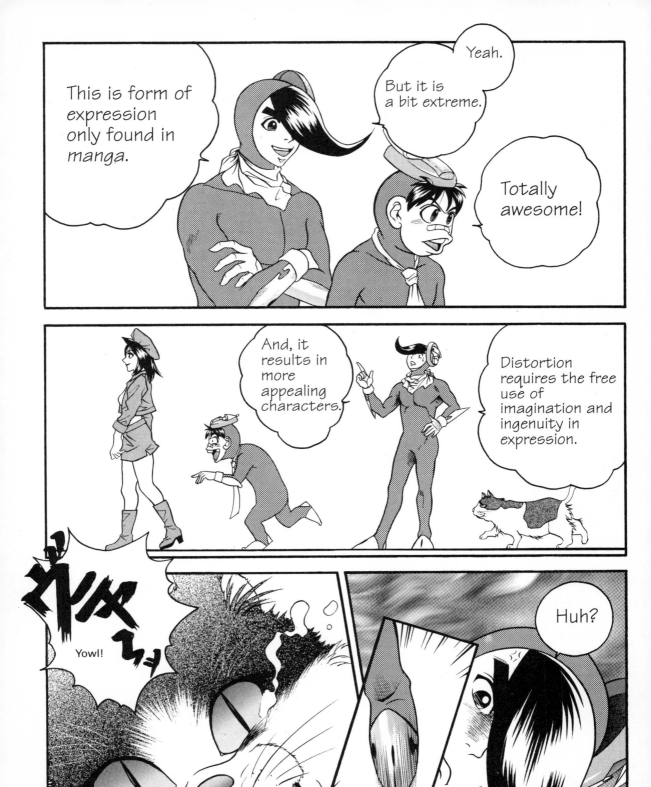

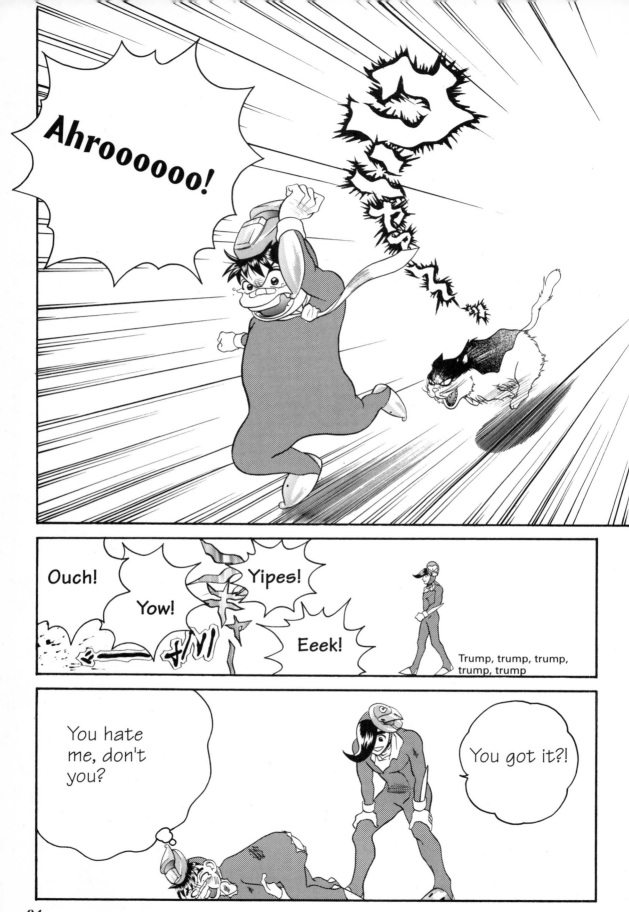

Chapter III

The Basics in Voice Portrayal

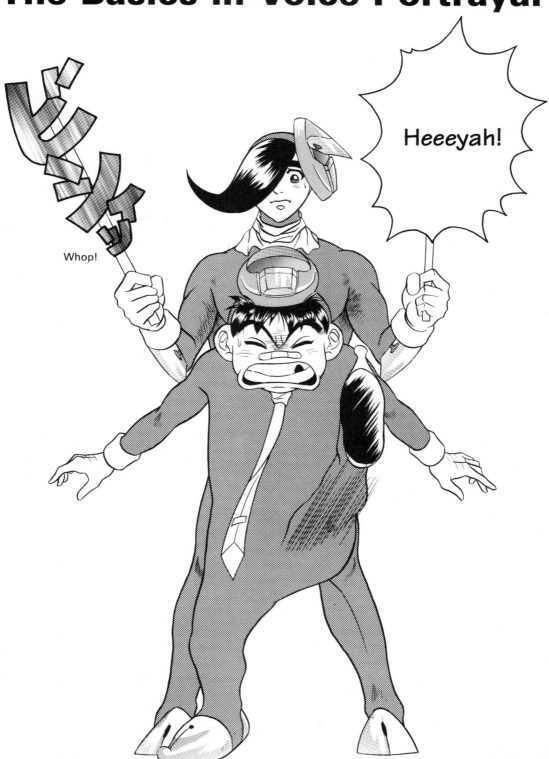

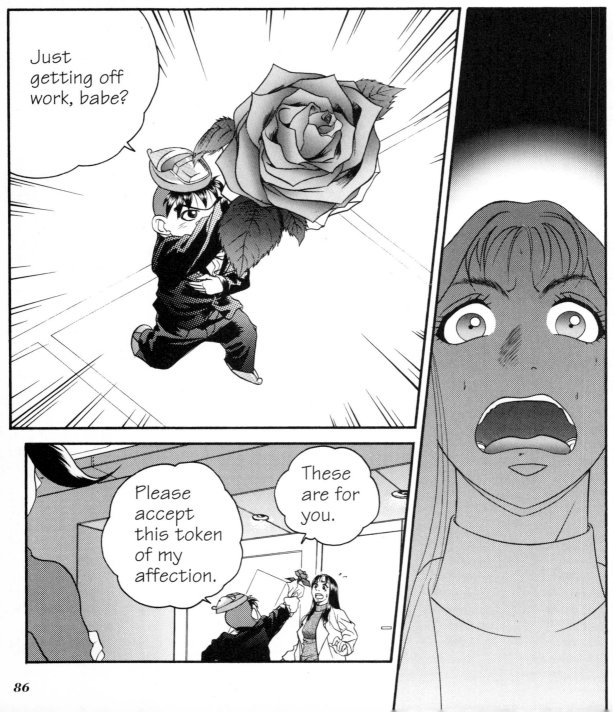

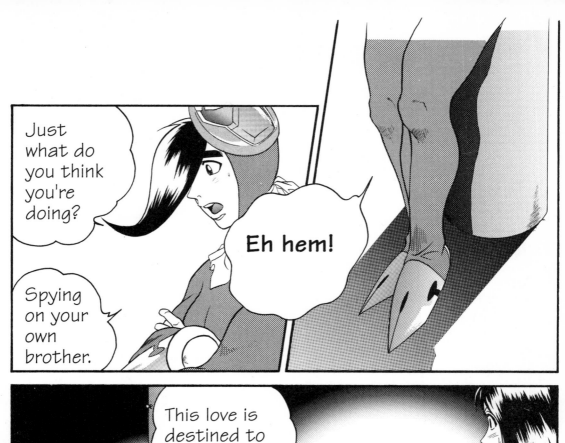

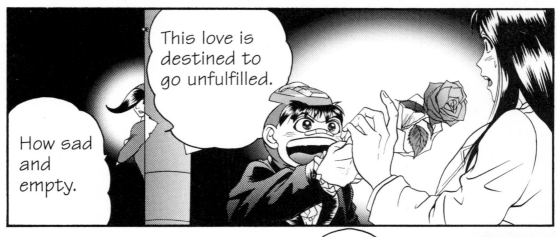

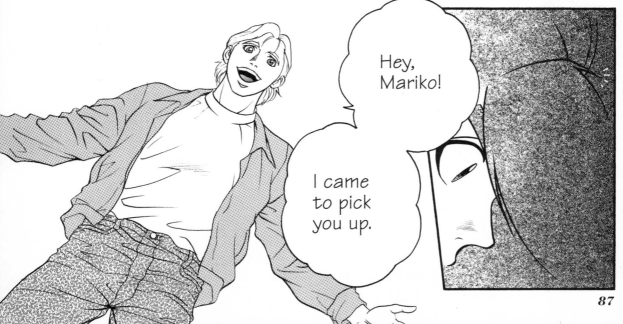

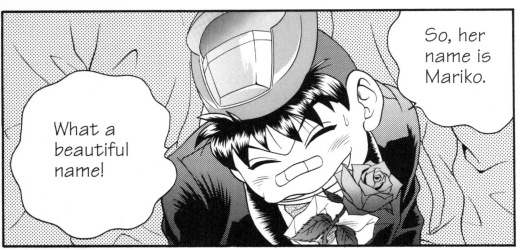

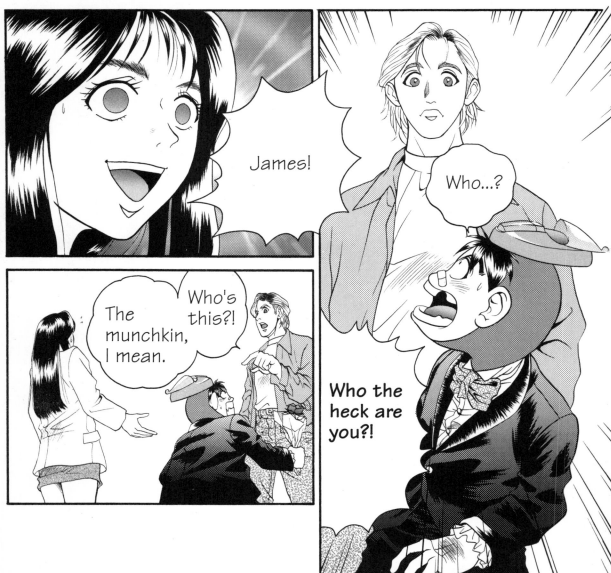

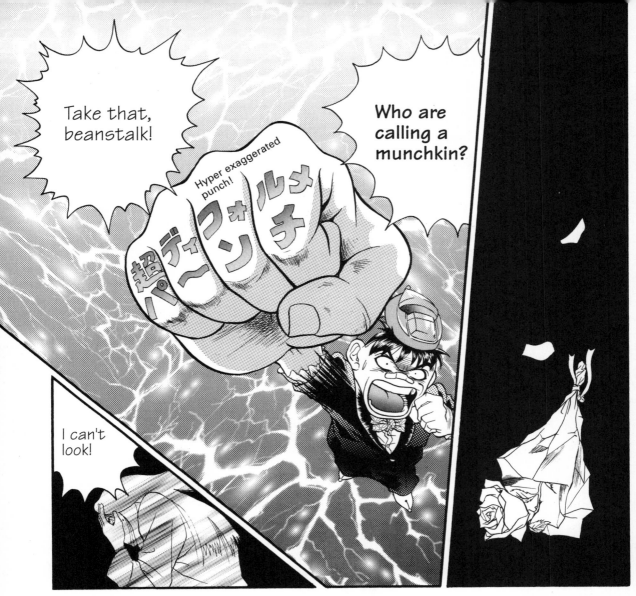

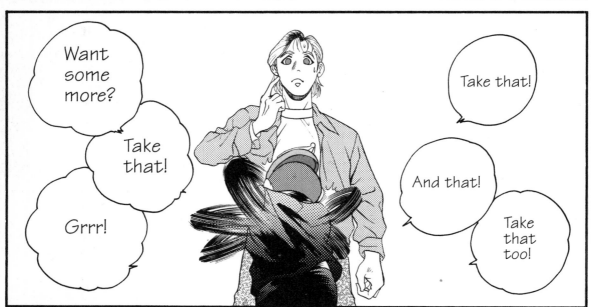

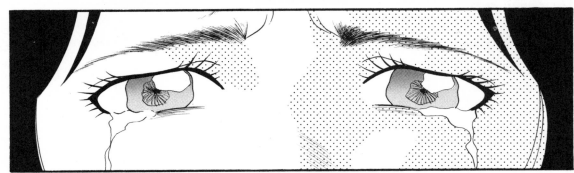

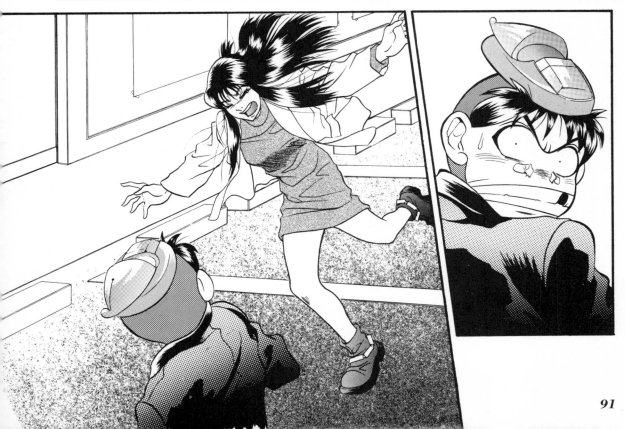

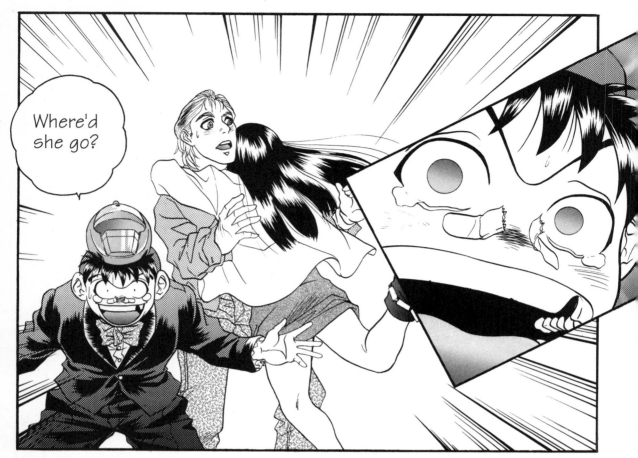

Where'd she go?

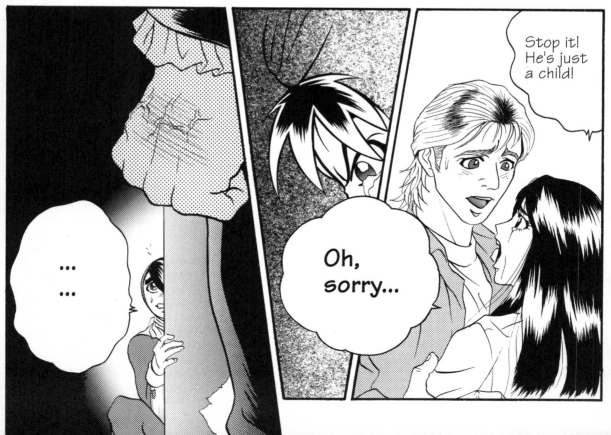

Stop it! He's just a child!

Oh, sorry...

... ...

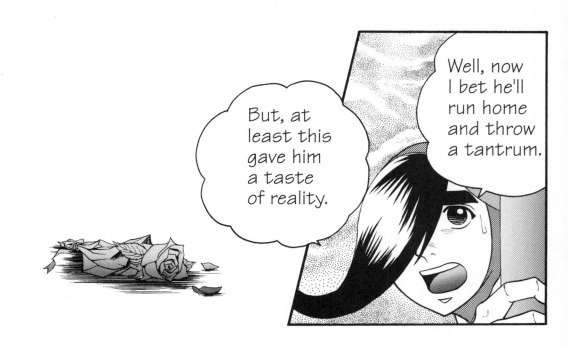

Well, now I bet he'll run home and throw a tantrum.

But, at least this gave him a taste of reality.

I wish I were good at fighting.

Rats!

If I were tough, she would want me.

Then again, I could be wrong.

There are no physical sound effects in *manga*. However, they can still be expressed. The sound effects used are the part of speech known as onomatopoeias and, just like dialogue, are expressed in lettering. Therefore, people believe sound effects may be used to the extent that they do not hinder the artwork, which in *manga* is given priority over text... But, is that truly enough?

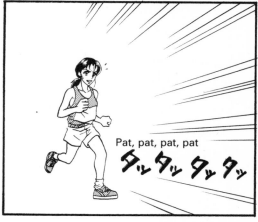

Pat, pat, pat, pat

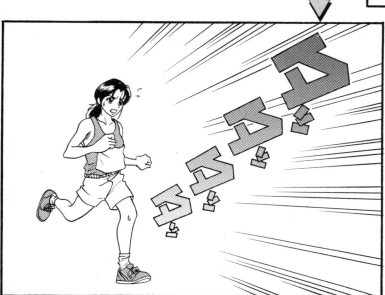

Representing the sound effects as part of the artwork will turn your composition into a powerful image, and draw out the character's presence.

First of all, we need to readjust our thinking. Sound effects and speech balloons are not text: they exist as part of the artwork. Sound effects and speech balloons contain emotion, and consequently are written in bold or display lettering. When the character laughs, so does her speech balloon. When the character becomes sad, the speech balloon takes on a gloomy form.

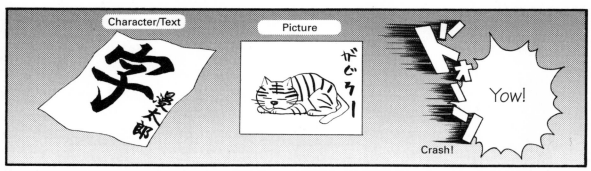

Sound effects and speech balloons are a form of representation unique to *manga* and comics, which unite lettering with artwork.

1. Portraying Volume

If you are wondering to yourself why your artwork just is not impressive, despite your characters' facial expressions being successfully rendered and having written witty dialogue or why a panel lacks vitality, despite having a terrific composition and being the key panel on the page, then take one more look at the original copy.

Just as your stereo or TV set has a volume knob, *manga* also has volume control, depending on the scene or speech line. Loud sounds or shouting voices are accordingly rendered in large lettering or speech balloons. Quiet sounds or whispers are rendered in smallish lettering or speech balloons.

I love you!

I love you!

I dunno about this one.

A volume knob

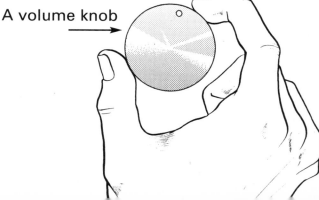

Filling the composition with sound effect lettering lets the scene have greater impact on the reader and gives plenty of fuel to the plot's development.

Sound effects and speech balloons do not necessarily have to be confined within the panel's borders. If you prefer to emphasize the speech line or sound even further, extending it outside the panel will effectively accomplish this.

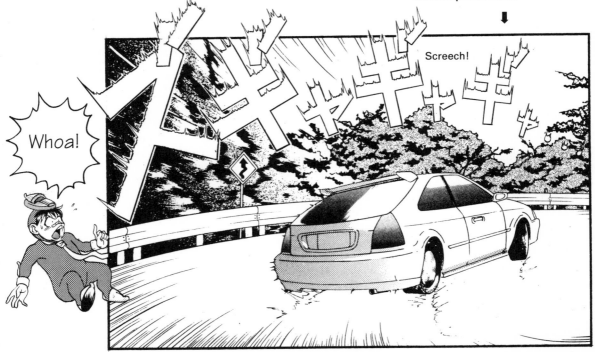

2. Sound and Voice Tones

Just as the character's facial expression matches his emotion, the speech balloon and sound effects likewise have expression. Rendering the voice, etc. in form suited to the emotion or sound makes this expression more convincing.

As shown in this example, emotional expression is contained within the shape of the speech balloon.

Let's look at a few more typical examples.

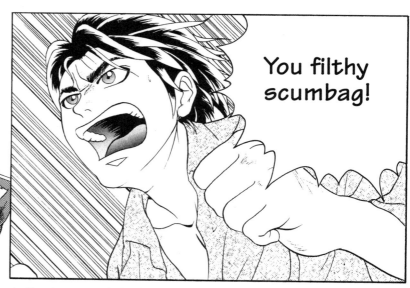

⬆ By the speech balloon's form containing emotional expression, the character's feelings are communicated more keenly, enhancing the scene's impact.

Sample Speech Balloons

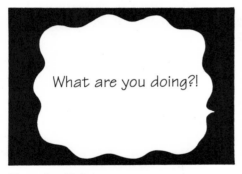

Negative Voice
The wavy circumference suggests an emotionally shaken voice. This form is often used to express "crying," "nervousness," "fear," and other negative emotions.

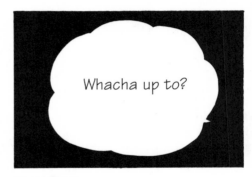

Basic Form
This is the form of speech balloon most commonly used for dialogue. It is essentially round in shape, but artists usually personalize it to allow their individual styles to come through.

Splash Balloon
The jagged shape of this balloon suggests the barbed tone of a strong emotion, portraying convincingly anger and shouting.

Explanatory Voice
This form evokes a sense of calmness and lack of emotion. It can also be used with voices projected through electronic transmission, such as through microphones or speakers.

Positive Voice
This speech balloon suggests an energetic, cheerful voice, appropriate to such positive emotional states as "laughing" or "pleasure."

Adding sound effects without giving the lettering any particular design will not make the image visually convincing. ➡

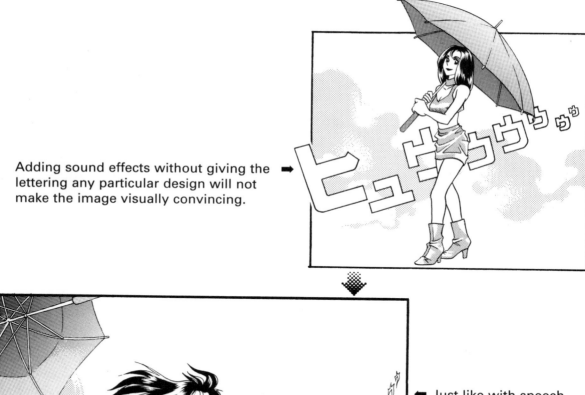

◀ Just like with speech balloons, manipulating the shape of the sound effect will allow the meaning to be conveyed to the reader all the more keenly.

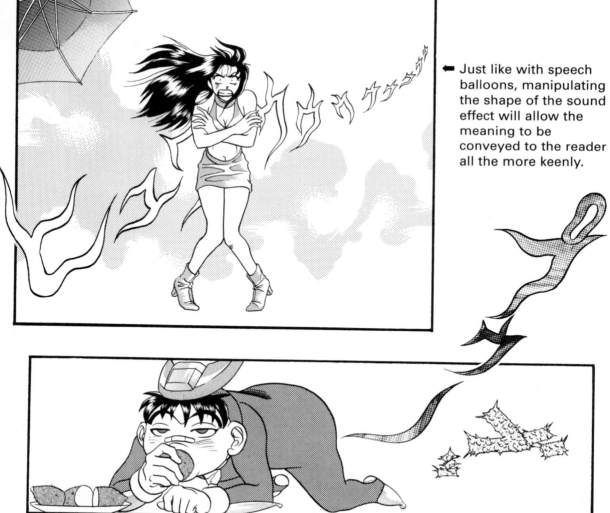

⬆ Changing shapes of the characters (lettering) conveys subtle tonal nuances-and in a single fart!

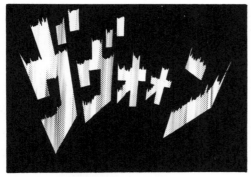

Explosive Sounds
Great for car engines, showing vibrating lines jutting out of the lettering projects the sense of a roaring report.

Crash Sounds
As the name implies, this is used to suggest crashes and bangs. The boldness of the lettering conveys the sound's impact.

Whispering
People have the tendency to assume that since whispering is a voice-produced sound, it ensues that a speech balloon must be used. However, if what is said cannot be heard clearly, then it is represented as a sound effect.

Jagged Sounds
Suggest the sharp sound of metal through jagged lettering.

Gooey Sounds
Giving a mushy texture to the sound effect conveys the sense of a sticky sound.

Hmmm.

I see.

3. Balancing Speech Balloons with Dialogue

The size of a speech balloon is not solely determined by the volume spoken. It is also determined by gauging the length of the copy. If the balloon is too small for the copy it contains, then it will make for difficult reading, and the overall composition will become cramped. On the other hand, if the balloon is too large, then the impact of the words becomes lost.

Whoa! What exactly do you want?

Hey Mantaro, Tell me how to draw manga. Tell me how to get girls. Tell me how to be happy. Aw, come on!

Dialogue Length

The editor adjusts the size of the font inside of the balloon to some extent. The common point size (typeset size) used for font in *shonen* and *shoujo* comics is 14 points, while 12 points is popular for *seinen* and ladies comics.

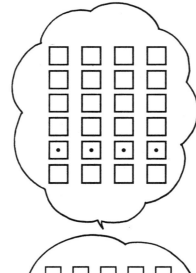

14 Points
This point size is primarily used for *shonen* and *shoujo* comics. Occasionally, pronunciation guides are added alongside the text in Japanese comics, so the characters are spaced at a sufficient distance within the balloon.

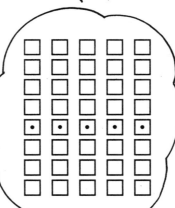

12 Points
The point size may change depending on the character's lines; however, this is the point size normally used for font in *seinen* and ladies comics.

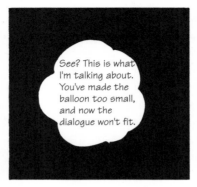

> See? This is what I'm talking about. You've made the balloon too small, and now the dialogue won't fit.

While you may use your imagination as you like to create new balloon designs, there are a few shapes that are just not acceptable. In order to ensure that the copy is easy to read and a satisfying composition is maintained, please avoid the following.

Here, the balloons have been pressed so snugly against the panel's borders, that they are almost unrecognizable as speech balloons. This will also cause the character's lines/balloon balance to be off kilter.

Above all else, it is essential that the balloon's shape be balanced with the lines contained. Refer to the preceding page, and try to ensure your speech balloons are well balanced.

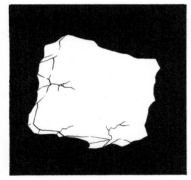

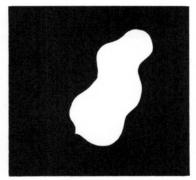

If the balloon is overly designed and blended into the background, then it may no longer be a speech balloon.

If the speech balloon is too unevenly shaped, you will find it impossible to arrange the character's lines coherently-plus the overall composition will be unsatisfying.

> The key to a successful speech balloon is to draw a well balanced, round balloon.

> Then, add touches to reflect the emotion felt.

4. Avoid Having the Character Talk to Him or Herself as a Narrative

In *manga*, there are 2 forms of copy outside of dialogue lines. The first is the character's inner voice or soliloquy. The second is a narrative guide to the story's happenings. Both serve to give the reader insight into the story's inner world or to a character's psyche. Depending on how these are designed, they could make or break the story, so careful consideration must be paid to how they will be used.

What should I do?

Soliloquy

Suzuri Suminohana, aged 20

She now faced the greatest trial of her life.

Narration

The Pros and Cons of Monologues

Internal monologues (soliloquies) reveal the character's hidden psyche and clarify the plot. The character becomes more appealing as a natural result, and the story's drama builds. In contrast, frequent use of soliloquies makes the character seem like he or she is happy just being alone and has trouble getting along with the other characters, causing the reader to be distracted from the main point of the character's behavior, obstructing the story's progress.

Don't go!

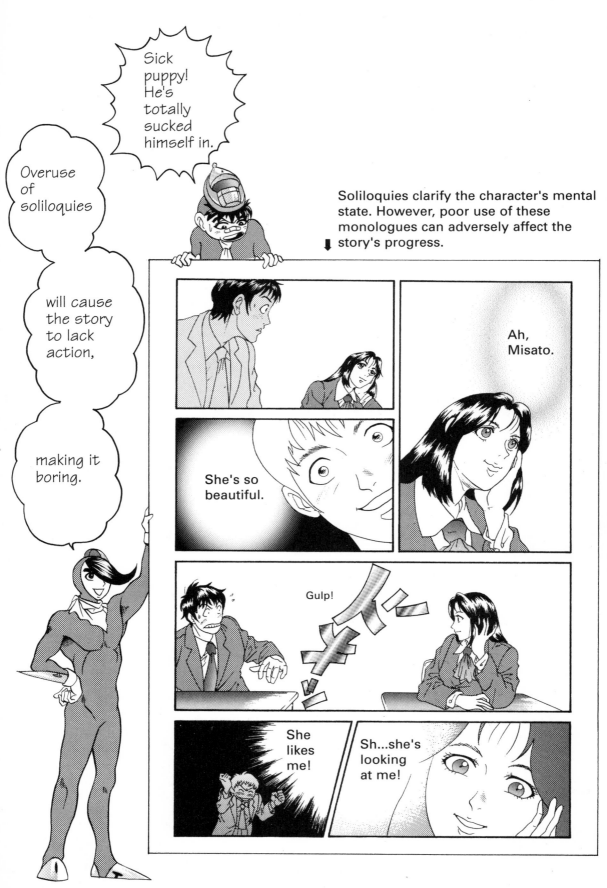

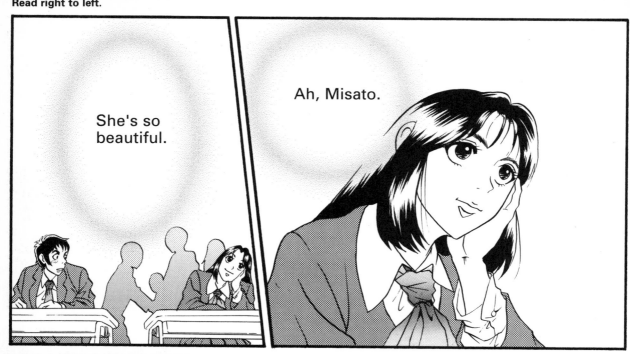

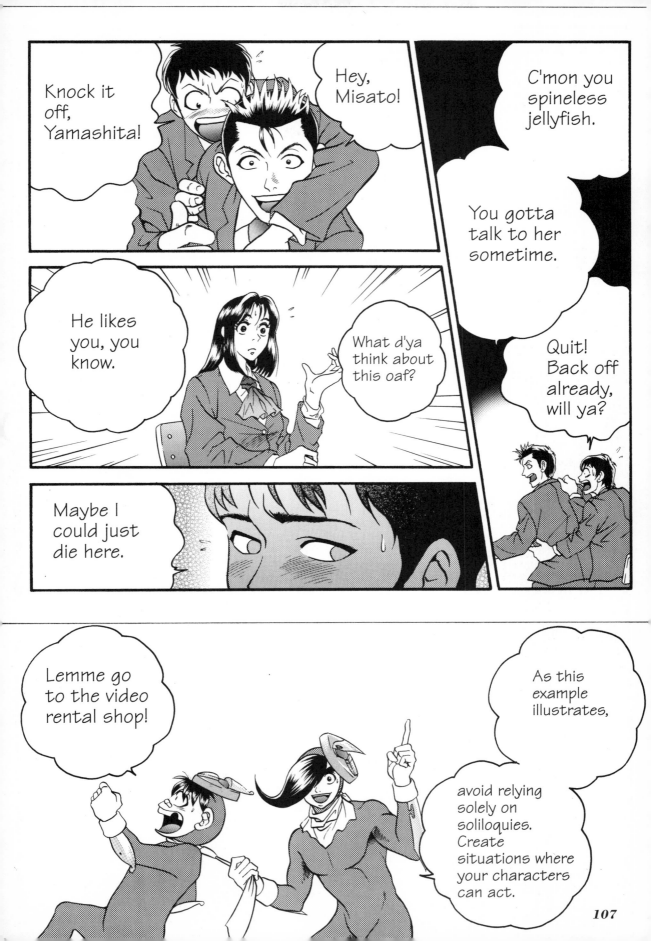

107

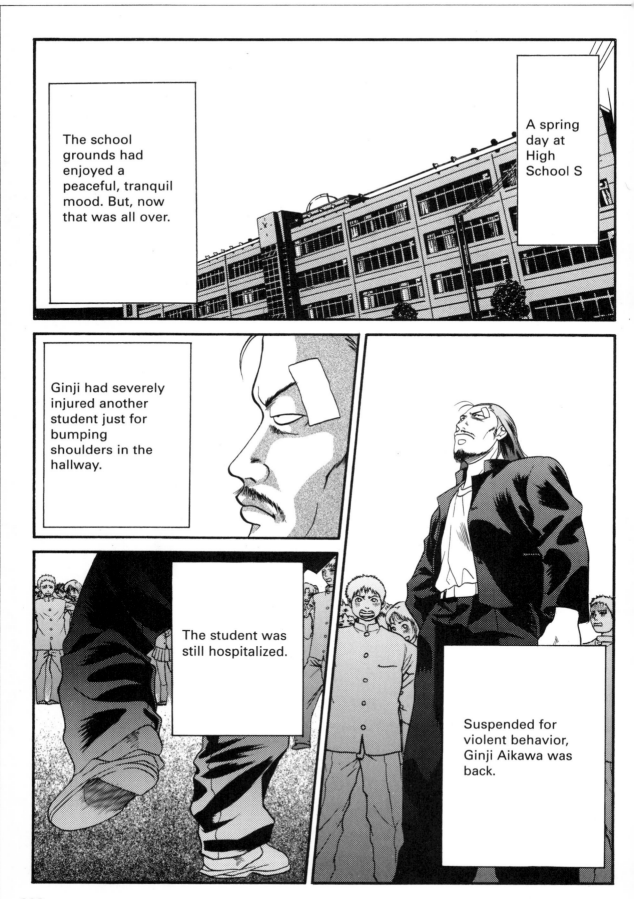

A spring day at High School S

The school grounds had enjoyed a peaceful, tranquil mood. But, now that was all over.

Ginji had severely injured another student just for bumping shoulders in the hallway.

The student was still hospitalized.

Suspended for violent behavior, Ginji Aikawa was back.

The Pros and Cons of Narration

Used to explain a setting or introduce a character, narration is an objective description of things and events. It is often used in a story's introduction. Since narration is comprehensible without illustration, it is extremely effective for fantasy stories, which take place in their own unique worlds.

However, as with internal monologues, overuse of narration can hinder your story's progress. This is because the artist may not stop at using narration to describe settings or characters, but may go so far as to have it describe a character or even what a character is thinking or his or her behavior. This defeats the purpose of having used manga as a medium in the first place.

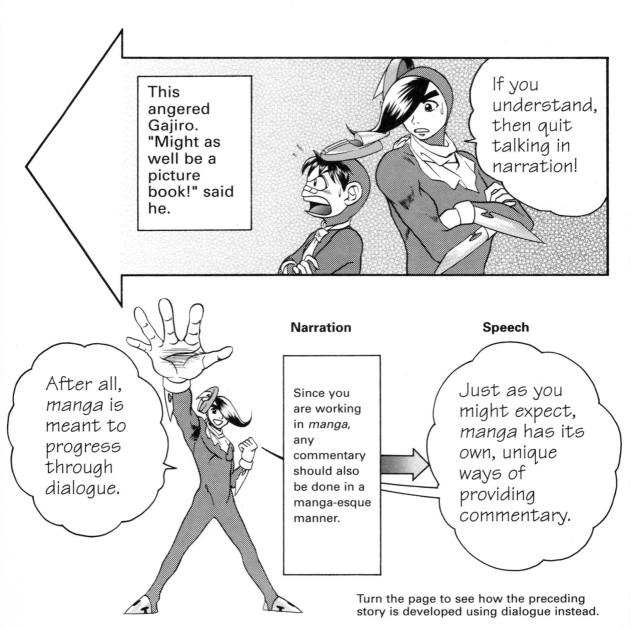

This angered Gajiro. "Might as well be a picture book!" said he.

If you understand, then quit talking in narration!

After all, *manga* is meant to progress through dialogue.

Narration

Since you are working in *manga*, any commentary should also be done in a manga-esque manner.

Speech

Just as you might expect, *manga* has its own, unique ways of providing commentary.

Turn the page to see how the preceding story is developed using dialogue instead.

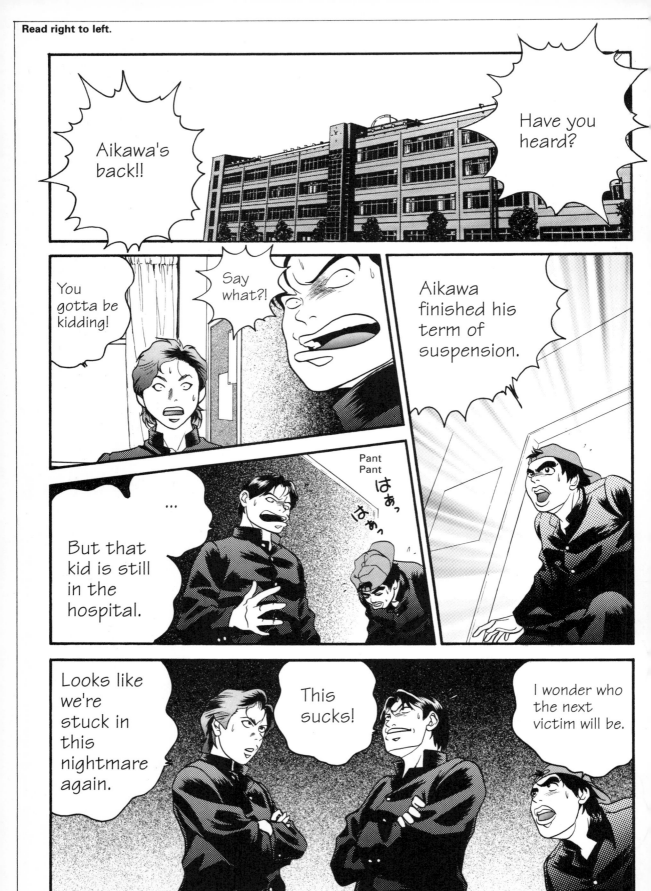

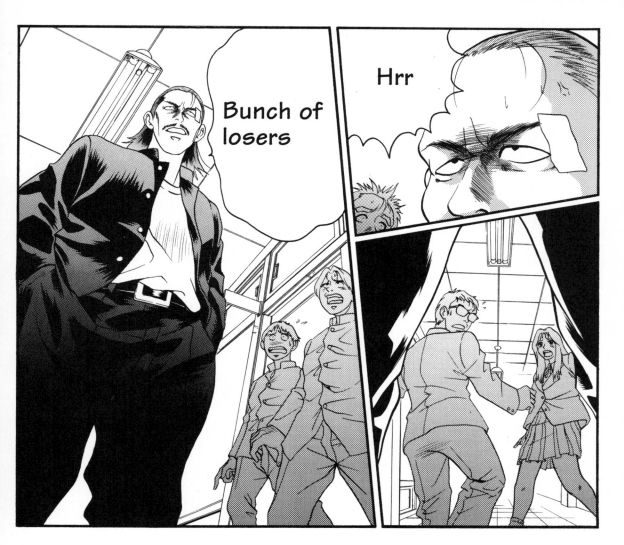

Bunch of losers

Hrr

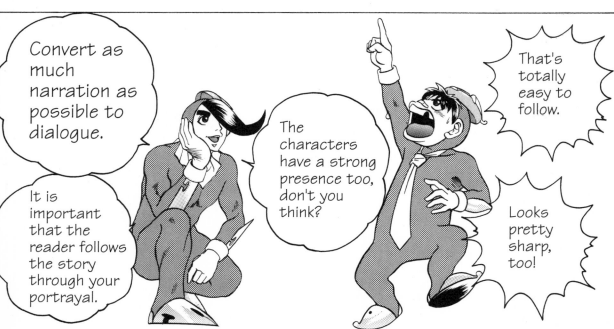

Convert as much narration as possible to dialogue.

It is important that the reader follows the story through your portrayal.

The characters have a strong presence too, don't you think?

That's totally easy to follow.

Looks pretty sharp, too!

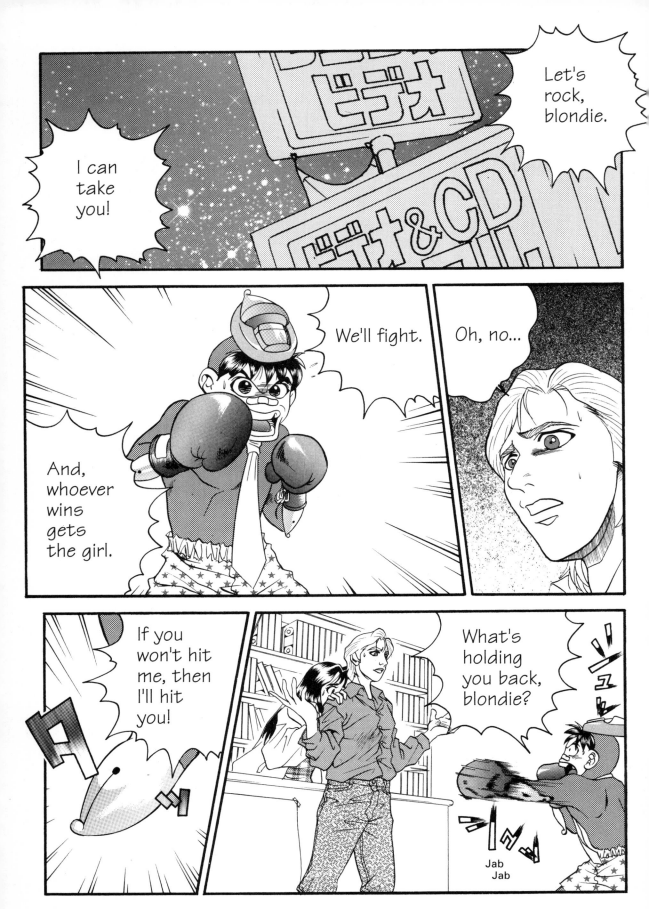

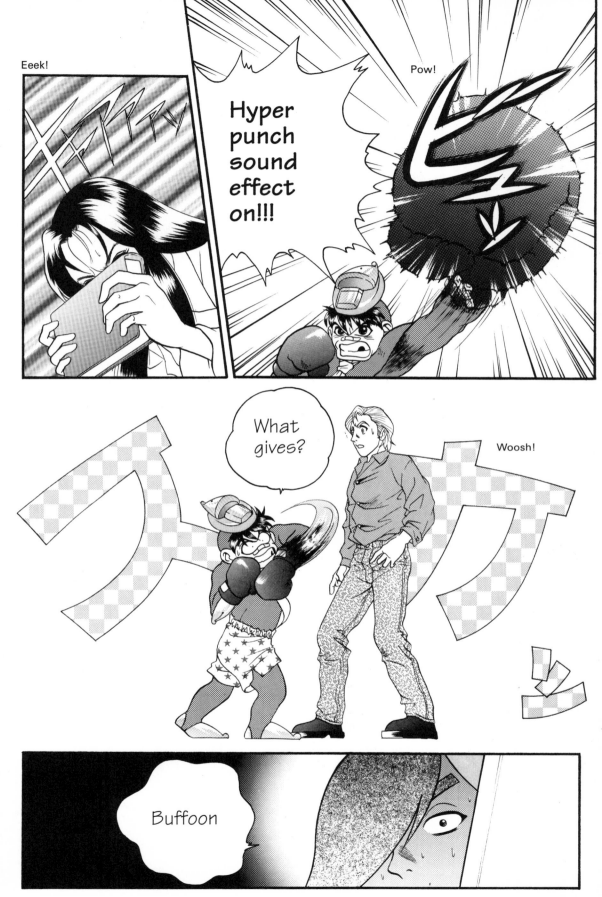

Since that day...

Gajiro, wait up!

Gajiro never showed his face in the shop again.

Chapter IV

The Basics in Panel Design

I created this *manga* all by myself.

Will you look at it for me?

S...sure.

Um... Penko.

Do you know anything about panel design?

So...

Did you like it?

1. Maintain a Balance in Spreads

Those readers who have taken their completed copies to a publishing company and were fortunate enough to have an editor look at their work probably noticed that the editor reviewed their copy 2 pages at a time.

⬆ In order to get a sense of compositional balance, the editor reviews the original copy 2 pages at a time, mimicking the spreads that would result if the work were published in a bound format.

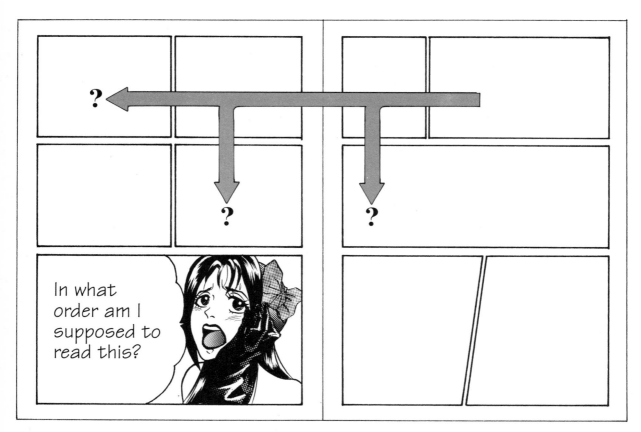

In what order am I supposed to read this?

⬆ In terms of overall composition, the first thing that you, the artist, should note is the panel layout. You must design your panels to ensure that the reader is easily able to follow the story. A bad example would be the above figure, where the panels are all aligned, and it is impossible to know in which order they are meant to be read.

Normally, panels in Japanese *manga* are designed to read from the right (even numbered) page to the left (odd numbered) page. Staggering the panels on the right and left pages will draw the reader's eye automatically along the correct flow.

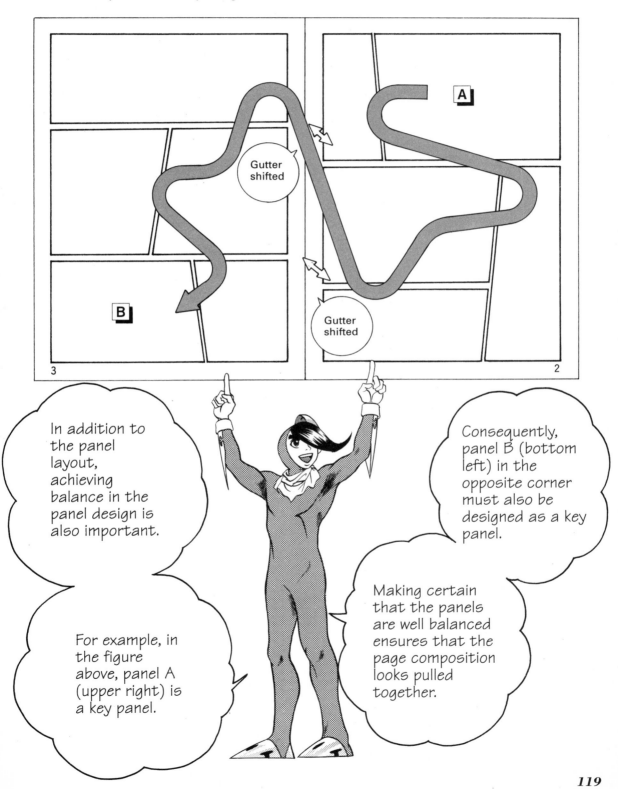

In addition to the panel layout, achieving balance in the panel design is also important.

For example, in the figure above, panel A (upper right) is a key panel.

Consequently, panel B (bottom left) in the opposite corner must also be designed as a key panel.

Making certain that the panels are well balanced ensures that the page composition looks pulled together.

2. The Panel's Shape Affects Movement.

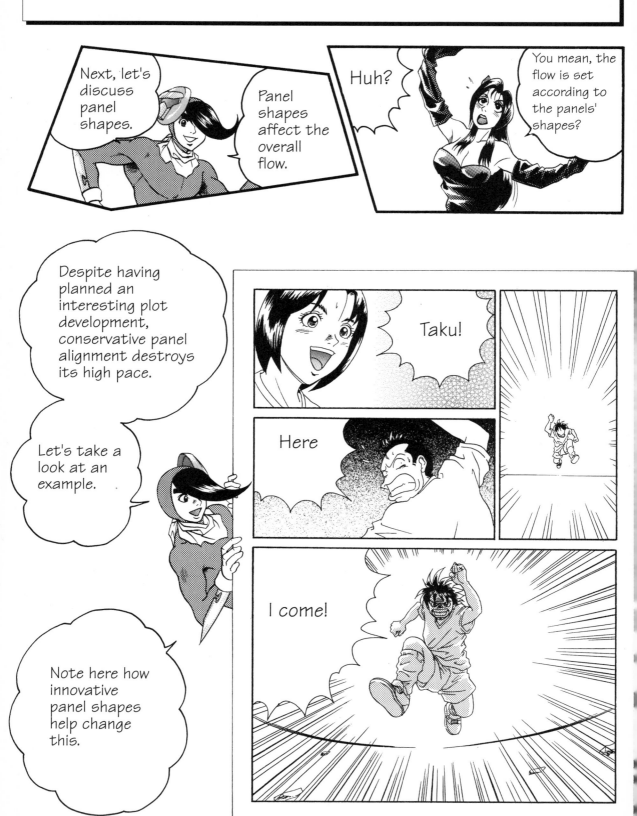

Next, let's discuss panel shapes.

Panel shapes affect the overall flow.

Huh?

You mean, the flow is set according to the panels' shapes?

Despite having planned an interesting plot development, conservative panel alignment destroys its high pace.

Let's take a look at an example.

Note here how innovative panel shapes help change this.

Taku!

Here

I come!

Innovative panel shapes facilitate the flow of the layout and allow for high-paced scene development. They particularly allow for action scenes with monumental impact.

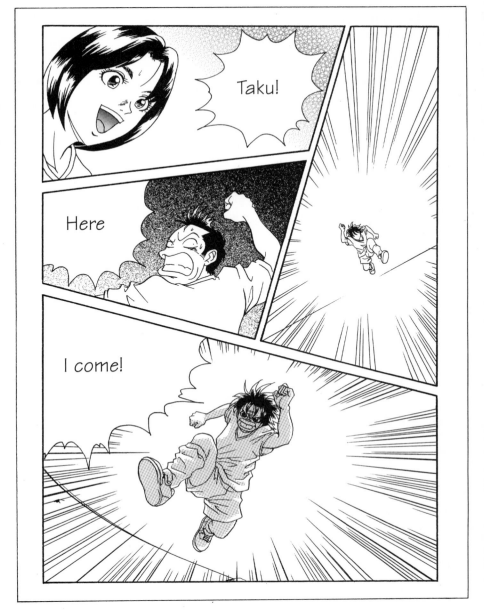

3. Use the Bleed to Add to the Composition.

The bleed is extremely effective for making a key scene all the more dramatic. It is an extremely valuable method of representation, allowing you to prevent your composition from becoming monotonous and clearly to distinguish the main points of the scene. Compositionally, simply making a panel larger will make it stand out. However, this does not mean that just having a given panel extend to the bleed will make it successful from a representational standpoint, just because it's easy to do. There are guidelines for using the bleed based upon the portrayal and effects desired.

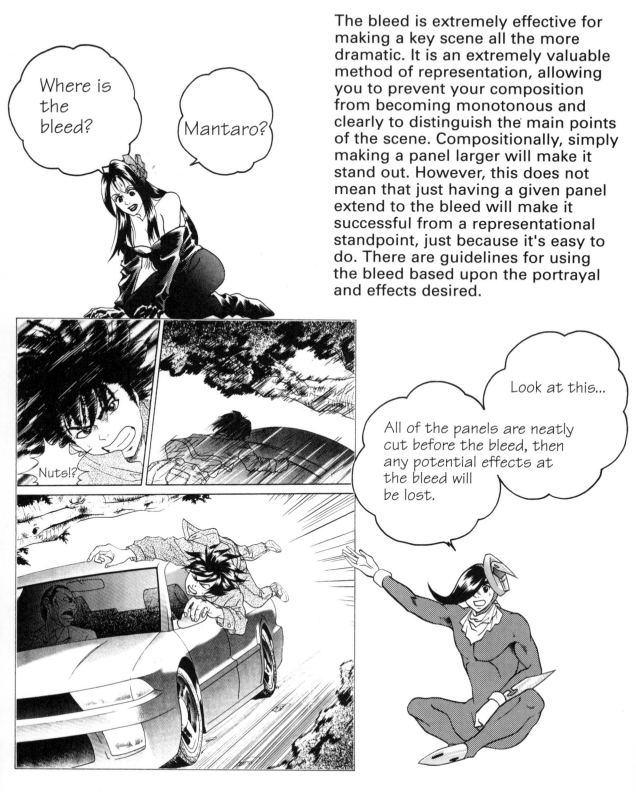

Where is the bleed?

Mantaro?

Nuts!?

Look at this...

All of the panels are neatly cut before the bleed, then any potential effects at the bleed will be lost.

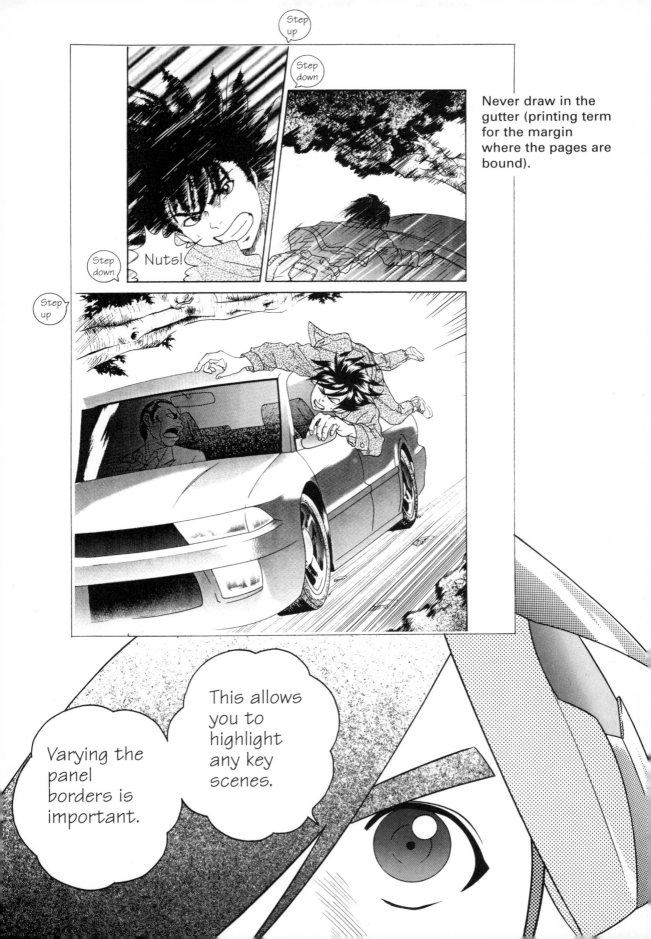

4. Use Panels to Suggest the Passage of Time.

Plots follow a sequence. On top of that, time exists within a story. There are many ways of suggesting the passage of time. Of these, the most common is the establishing panel.
Establishing panels are all of the panels lying between incidents in the story. Establishing panels are used to organize the story's pace.

Below are a number of establishing panels we picked up.

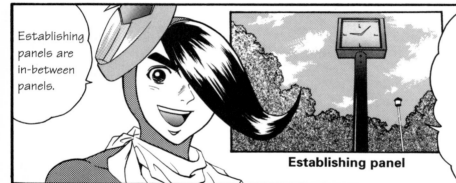

Establishing panels are in-between panels.

Establishing panel

They are background panels used to suggest the passage of time or establish the setting.

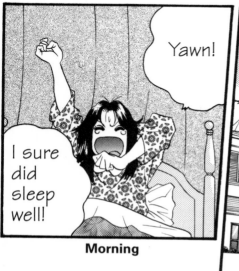

Yawn!

I sure did sleep well!

Morning

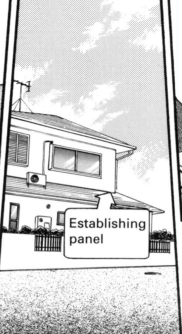

Establishing panel

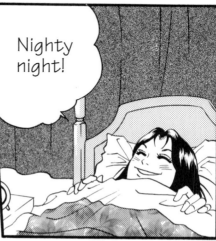

Nighty night!

Night

124

Suggesting the Passage of Time

There are various ways available in manga for suggesting the passage of time. Let's look at a few examples.

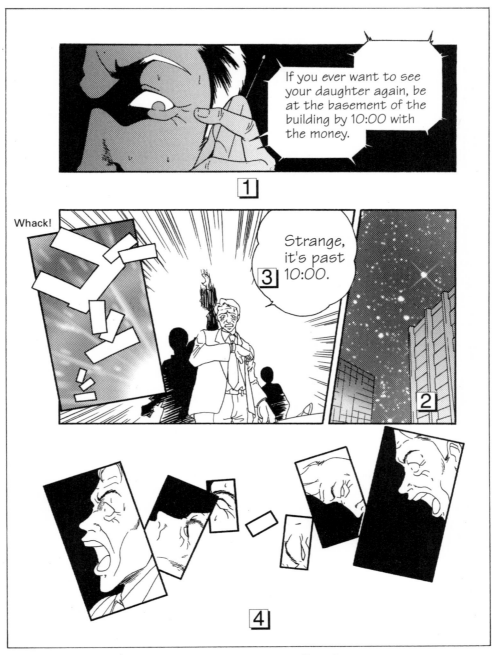

1. **Panel Borders**: Thickening a panel's borders creates a line drawn between the panel sequence, suggesting that time has passed between the 2 panels.

2. **Establishing panel**: Refer to the preceding page.

3. **Speech**: Time can be expressed through a character's lines. However, this technique is less impressive than showing the passage of time visually.

4. **Fade in/Fade out**: Using fading as a sequence effect allows you to suggest the passage of time in a subjective context. This is particularly effective for showing a character "sleeping" or "fainting."

5. Use Open Doors to Reveal a Key Panel.

There is a trick to panel design that is closely connected to human nature, and that is to liken the act of turning a page to the psychology behind opening a door. This enables you to draw the reader's interest.

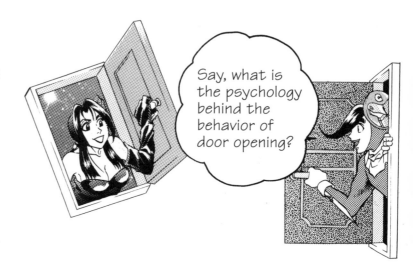

Say, what is the psychology behind the behavior of door opening?

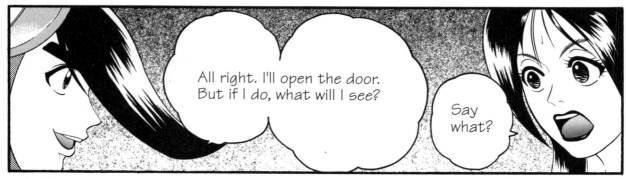

All right. I'll open the door. But if I do, what will I see?

Say what?

The Psychology behind Opening a Door

First, consider the point of view.

We naturally sights are set on the target. But, in the case of a door, our sights normally set on what is on the other side of that door. Now, what if we were to transfer this psychology to the act of turning a page.

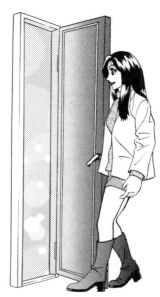

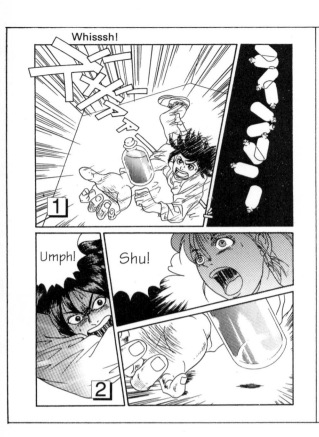

When we turn a page, our eyes focus before all else on panel 1 above. This is because we first read the right page, which can be likened to the backside of a door. The reader gains an impression of the work's content from this panel. Therefore, the reader will become interested in the work if this panel is designed to be a key scene or other such exciting contents.

Panel 2 above then serves to draw the reader's interest even further. If it is designed to allow the reader anticipation of upcoming plot development, then the reader will be hooked, and will turn another page.

It is crucial that you use the story's interest to lure the reader.

However...

Using panel design to entice the reader's psychology is another vital aspect of manga.

6. Use the Layout to Create a Key Scene.

All you've been talking about are "key scenes." Just how do you create a "key scene"?

Well, I...um (gulp)!

Ok. Let's talk about good layouts.

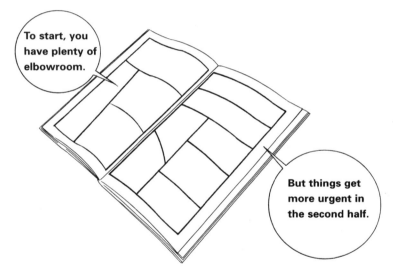

To start, you have plenty of elbowroom.

But things get more urgent in the second half.

Ways of approaching layouts depend on the individual artist. There are those who lay out the panels on a piece of notebook paper, while others will use copier paper or the flip side of a magazine flier. There are those who will just do a rough sketch, while others will draw the layout in as much detail as an under drawing. However, the vast majority will determine the panel design when establishing the layout.

You will find that in the beginning of a work, layout is a relatively easy process. However, artists often find they need more pages once they have progressed to the second half. As a consequence, key scenes constituting the story's climax are relegated to smaller panels-a far from ideal situation.

Layouts That Create a Key Scene

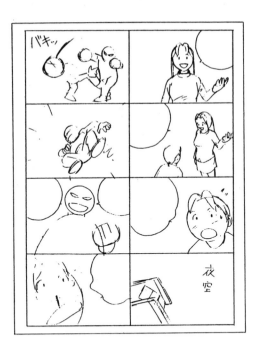

[1] To start, divide a sheet of paper (notebook) into about 6 to 8 panels (average panel count). Next, the sequence is decided.

[2] Once the sequence is set, write a number on each panel. Then, divide the total number of panels by the expected number of pages.

E.g.: (total # of panels) ÷ (expected # of pp.)
145 panels ÷ 23 pp. + 1 splash page = 6 panels

(If the number cannot be divided evenly, then round to the nearest 10's place, round down for numbers ending in 4 or less and up for 5 or more.)

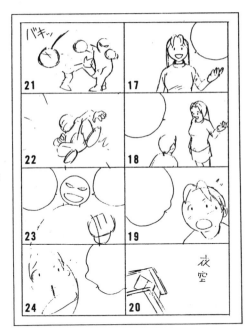

In other words, the total panel count divided by the expected number of pages yields...

...the average number of panels per page.

Keep this number in mind when deciding the panel layout.

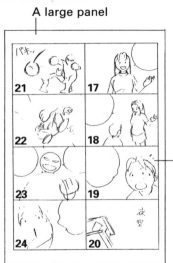

A large panel

A mediumpanel

3 Keep track of where you have placed key panels or enlarged panels throughout the work.

There are various ways of marking to keep track. Use whatever method makes you feel comfortable.

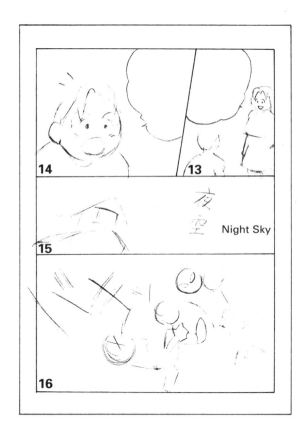

Night Sky

This will minimize your mistakes in laying out the panels and will allow you to portray your key scenes properly.

4 Design your panel layout around any marked panels. If you cannot fit some of the panels planned onto the page owing to the presence of a large panel, etc., defer the remaining panel(s) to the following page, and adjust the layout accordingly. For example, move panels 17 and 18 to the next page and give that page an 8-panel layout.

Chapter V

The Basics of *Manga* Portrayal

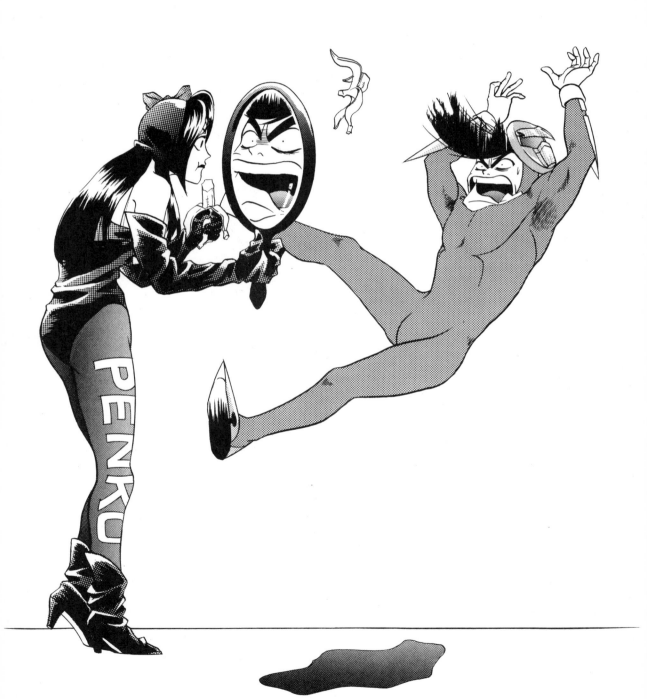

1. Step into the Character's Shoes.

And now the final wrap up!

The basics of manga portrayal.

Everyone has probably faced the problems of how to make his or her *manga* more interesting or how to make the story more dramatic. But, just what sort of *manga* is interesting?

I wonder what makes it so.

Oh, this is interesting.

In order to fill these requirements, the artist must shorten the distance between the reader and the story. This means that the artist is faced with the task of how to give the reader, who is an objective observer, a subjective perspective, so that he or she may feel part of the story.

First and foremost, manga conveys a story centered on the protagonist(s). Obstacles arise in the main character's path, action is taken, and then conflicts are resolved.

During this process, the protagonist experiences many emotions and handles the situations he or she is dealt. Anger, sadness, worry, and joy-the reader is allowed to participate by feeling an affinity with the main (or other character)'s emotions or the story's theme.

So then, let's look at the example of "slipping on a banana peel" to illustrate this definition, composing an objectively observed situation to a subjective one.

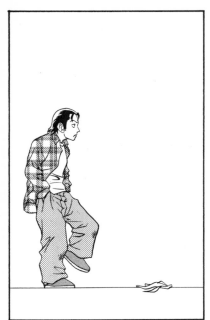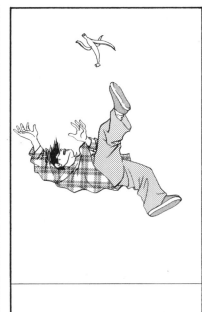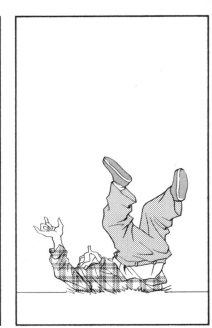

Slipping on a Banana Sequence

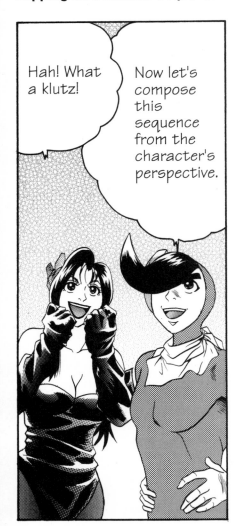

Hah! What a klutz!

Now let's compose this sequence from the character's perspective.

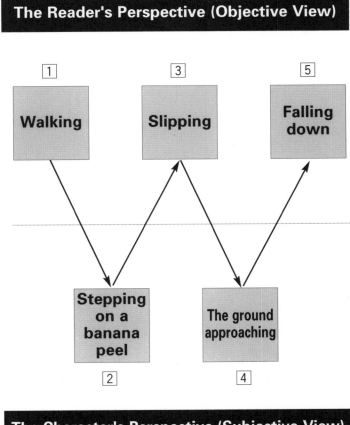

The Reader's Perspective (Objective View)

1 Walking
3 Slipping
5 Falling down

2 Stepping on a banana peel
4 The ground approaching

The Character's Perspective (Subjective View)

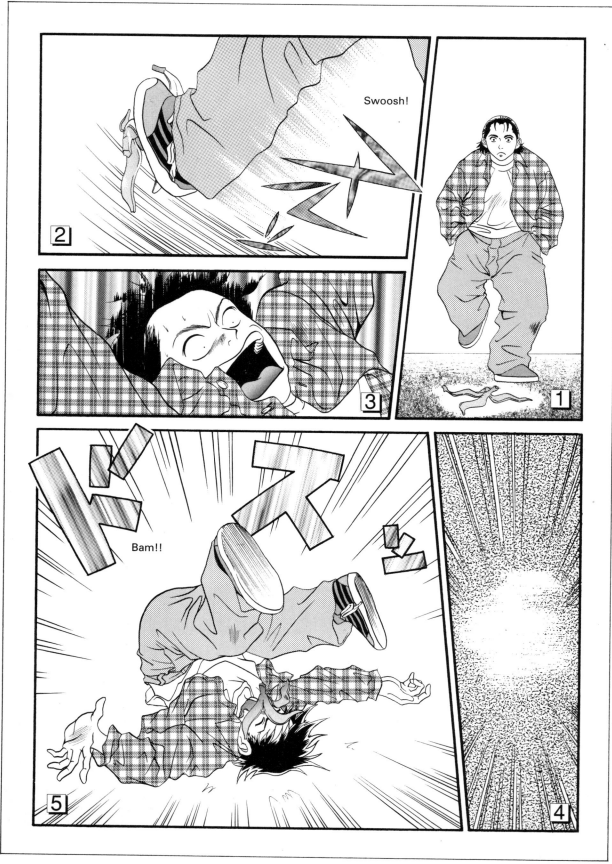

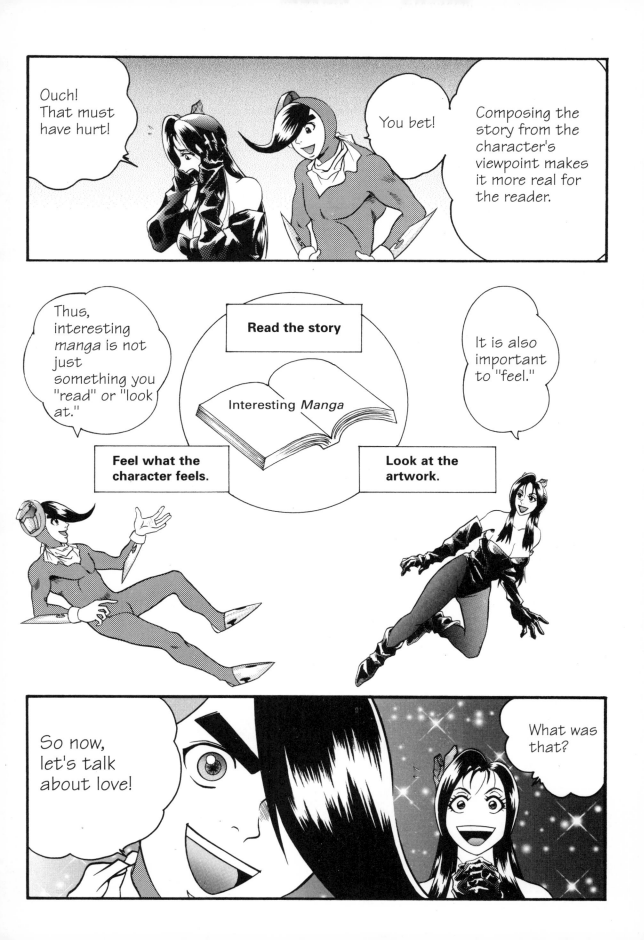

2. Have Romantic Encounters begin with Impact.

Everyone experiences romance at some point in time. The wonderful thing about romance is that despite its multifarious associated emotions, felt openly or secretly, and its diversity in expression, the reader is able to accept and sympathize with the characters wholesale. For that very reason, it is vital that the artist paint a picture of love that conveys the characters' feelings and emotions to the reader. Since love is something everyone is capable of understanding, you, the artist, must express what you have personally felt.

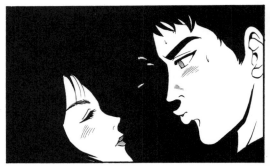

⬆ Love stories are not told through reason alone. Accordingly, the story must be able to express itself in a convincing manner.

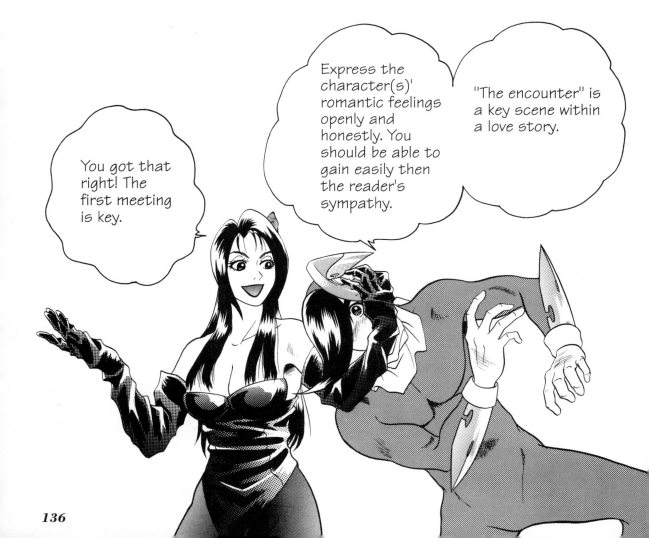

You got that right! The first meeting is key.

Express the character(s)' romantic feelings openly and honestly. You should be able to gain easily then the reader's sympathy.

"The encounter" is a key scene within a love story.

This example is really beyond the point. While there are people out there who are this aggressive, the conclusion is just a little too easily reached to make an interesting story.

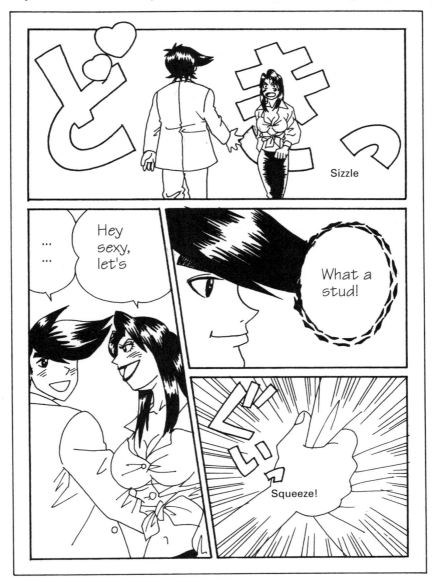

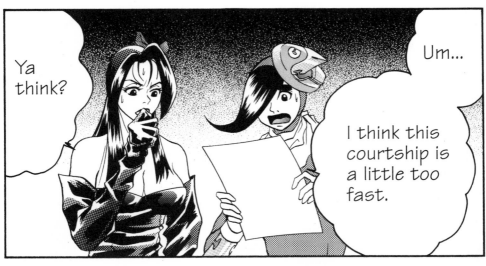

The Appeal and Purpose of Romance *Manga*

In romance *manga*, the protagonists' objectives are extremely clear, and the story always ends with either broken heart or the formation of a new couple. The charm of romance *manga* lies in the courtship up to the story's climax. For example, even supposing the story ends happily, if the all-important courtship is not engaging, then the story overall, in other words, the work as a whole, will be judged poorly.

The courtship is made interesting by setting up exciting plot developments. The key is to make the reader anxious about what turns the story will take by establishing circumstances or conditions where one character cannot approach the other, or adding a rival who thwarts the hero's efforts. Then, by portraying the protagonist's feelings within the panel, the reader immediately gains genuine feelings of empathy for the character.

Skillful composition of subjective and objective views yields a more forceful impact without dialogue than with, and makes the scene all the more dramatic.

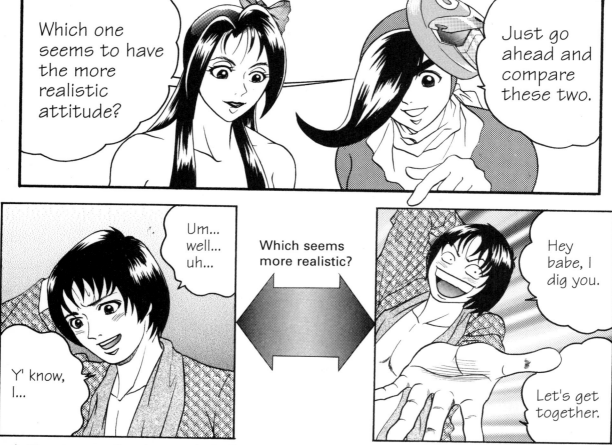

⬆ The stronger the character's feelings are, the more difficult it should be to communicate them. If the character is able to express his or her feelings glibly, this may conversely make those feelings seem false, causing the reader no longer to believe in the story. Modes of expression going beyond words make the story seem more real.

Portraying Romantic Encounters in *Manga*

The first encounter, the beginning of a romance, must have impact. To put it another way, the encounter constitutes the reader's first impression of the *manga*.

Point 1: How the two meet is the most important aspect of the encounter. The degree of impact of this meeting establishes the future distance between the two.

Point 2: The close-ups (see Chapter II, Section [7]) enhance how stunned the character appears and allow the reader to hold expectations regarding future plot developments.

Point 3: The large panel enhances the subjective view, allowing the reader to share the boy's impression of the girl.

Point 4: Her gesture of brushing back the long hair alludes to her femininity, giving her appeal, strengthening his feelings toward her.

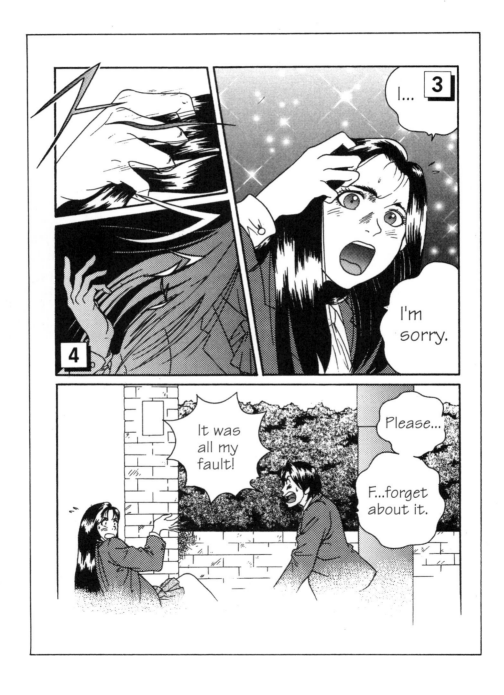

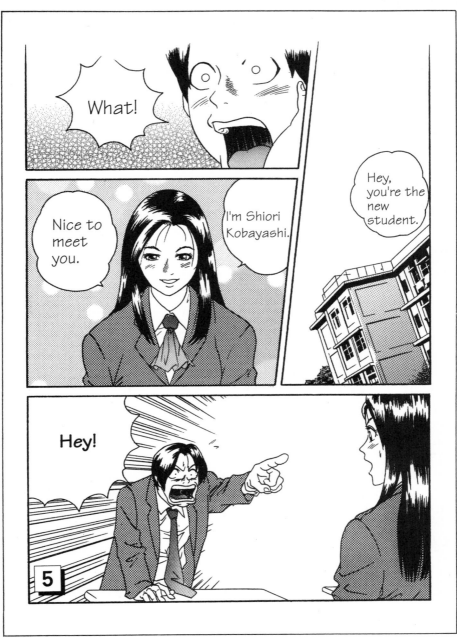

Point 5: While this type of encounter may seem a little trite, the concept of having met before is extremely effective for increasing the tension between the two. Thanks to Point 1, the relationship between the two has been slickly established, which will facilitate the story's progression.

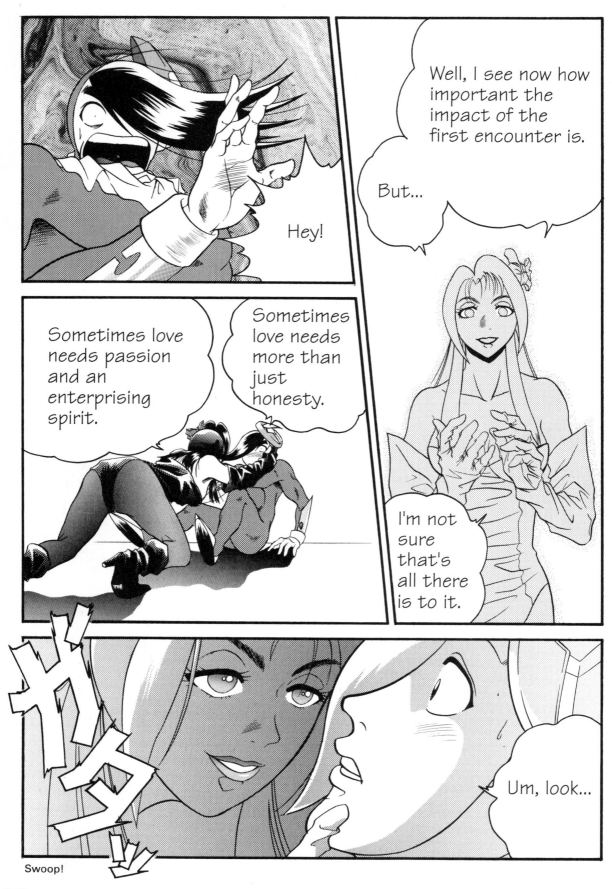

Swoop!

142

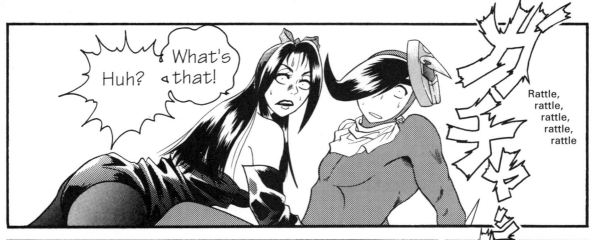

Huh? What's that!

Rattle, rattle, rattle, rattle, rattle

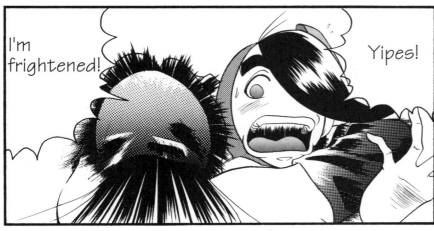

I'm frightened!

Yipes!

Why don't you open the door and act scared?

Hey, Penko. This seems like a good opportunity.

Do I have to?

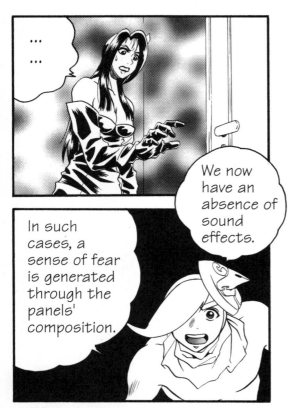

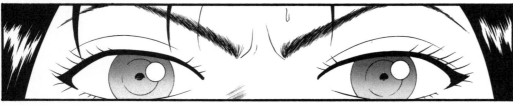

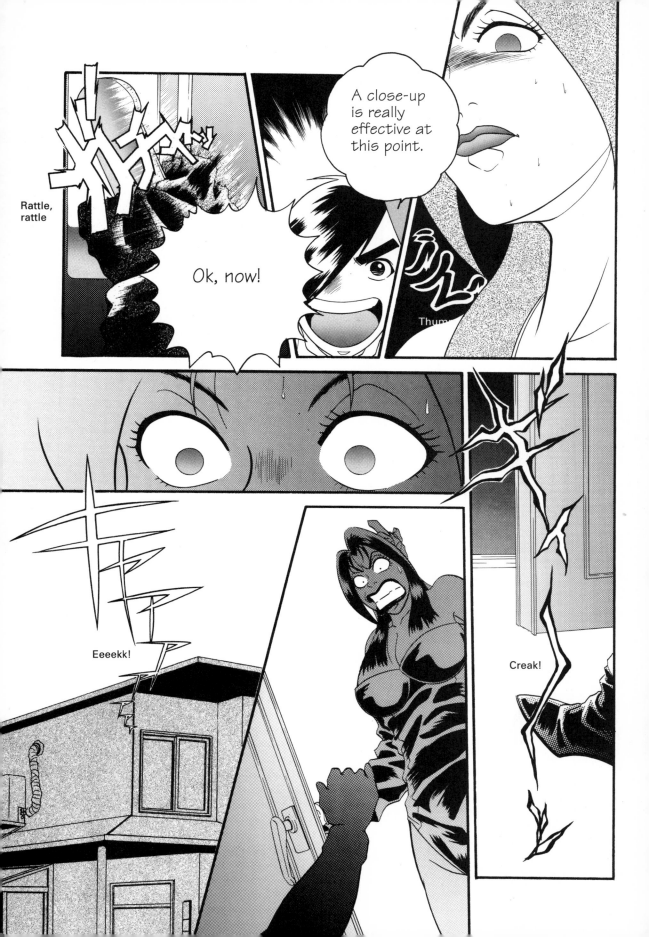

Mantaro, I give up on girls.

I'm going to devote myself more fully to manga.

Penko!

Gajiro!

Wow!

Grope!

147

THE END